W9-BYJ-317

Dream
Catchers

Dream Catchers

LEGEND, LORE AND ARTIFACTS

CATH OBERHOLTZER

FIREFLY BOOKS

LINDENHURST MEMORIAL LIBRARY
LINDENHURST, NEW YORK 11757

A FIREFLY BOOK

Published by Firefly Books Ltd., 2012

Copyright © 2012 Firefly Books Ltd.
Text copyright © 2012 Cath Oberholtzer

All rights reserved. No part of this publication may be reproduced, stored in a retrieval system or transmitted in any form or by any means, electronic, mechanical, photocopying, recording or otherwise, without the prior permission of the Publisher.

First printing

Publisher Cataloging-in-Publication Data (U.S.)

Oberholtzer, Cath (Catherine)
 Dream catchers : legend, lore and artifacts / Cath Oberholtzer ;
 original dream catchers by Nick Huard.
[144] p. : ill., photos. (some col.) ; cm.

ISBN-13: 978-1-77085-056-9
1. Dreamcatchers. 2. Ojibwa Indians – Religion.
3. Ojibwa art. I. Huard, Nick. II. Title.

971.004/973 dc23 E99.C6.O247 2012

Library and Archives Canada Cataloguing in Publication

Oberholtzer, Cath (Catherine)
 Dream catchers : legend, lore and artifacts / Cath Oberholtzer.

ISBN 978-1-77085-056-9

1. Dreamcatchers. 2. Ojibwa Indians--Religion.
3. Ojibwa Indians--Social life and customs. 4. Ojibwa mythology.
5. Ojibwa art. I. Title.

E99.C6O34 2012 971.004'97333 C2012-901994-1

Published in the United States by
Firefly Books (U.S.) Inc.
P.O. Box 1338, Ellicott Station
Buffalo, New York 14205

Published in Canada by
Firefly Books Ltd.
66 Leek Crescent
Richmond Hill, Ontario L4B 1H1

Cover and interior design:
Janice McLean / Bookmakers Press Inc.

Printed in China

The Publisher gratefully acknowledges the financial support for our publishing program by the Government of Canada through the Canada Book Fund as administered by the Department of Canadian Heritage.

Acknowledgments

No project reaches fruition without the assistance of many people, and I am indebted to a great number of individuals who have willingly shared information, photographs and actual dream catchers over the years. My gratitude is extended to Trudy and John Nicks, Alison Brown, Tabitha Cadbury, Debbie Cochrane, Gerry Conaty, Stephen Cook, Alan Corbiere, Leslie Dodds, Bernie Francis, Sue Giles, Richard Green, Judy Hall, Rachel Hand, Susan Haskell, Nick Huard, Stephen Inglis, White Wolf James, Mi'sel Joe, Chantal Knowles, Ken Lister, Anne Marin, Damian MacSeain, Ruth McConnell, Ann McMullen, Beth Oberholtzer, Ron Oberholtzer, Katherine Pettipas, Kim Reid, Angela Robinson, Donald Smith, Nick Smith, Sandra Weizman, Bill Wierzbowski and Laila Williamson. Needless to say, if I have overlooked anyone, it was inadvertent.

Nor does a book come to print without a competent publishing house behind it. The invitation to prepare this manuscript was proffered by Michael Mouland (on the advice of Trudy Nicks) and encouraged by Firefly Books publisher Lionel Koffler. The final product came about thanks to the team at Bookmakers Press, with editor Tracy C. Read and copyeditor Susan Dickinson bringing a critical perspective, a sharp eye and a deft touch to the text, while art director Janice McLean contributed her talents with a lovely original design. To all of them, a sincere thank you.

About the Author

CATH OBERHOLTZER

Currently a conjunct professor in the Anthropology Department at Trent University, in Peterborough, Ontario, and a research fellow with the Trent University Archaeological Research Centre. Cath Oberholtzer began her career as an archaeologist. While her original focus was on the prehistory of southern Ontario, that shifted to cultural anthropology when she began to research the early material history of the Crees in numerous museums. In addition to undertaking archival research related to the early British and Scottish presence in the James Bay area, she has gathered firsthand accounts from members of the Cree communities on the coasts of James Bay, participated in workshops with the Crees at Val-d'Or, Quebec, written extensively about Cree material culture and lectured on the aboriginal art of the Americas. Dr. Oberholtzer lives in the historic town of Cobourg, Ontario, where she is actively involved in a number of organizations and social groups.

Contents

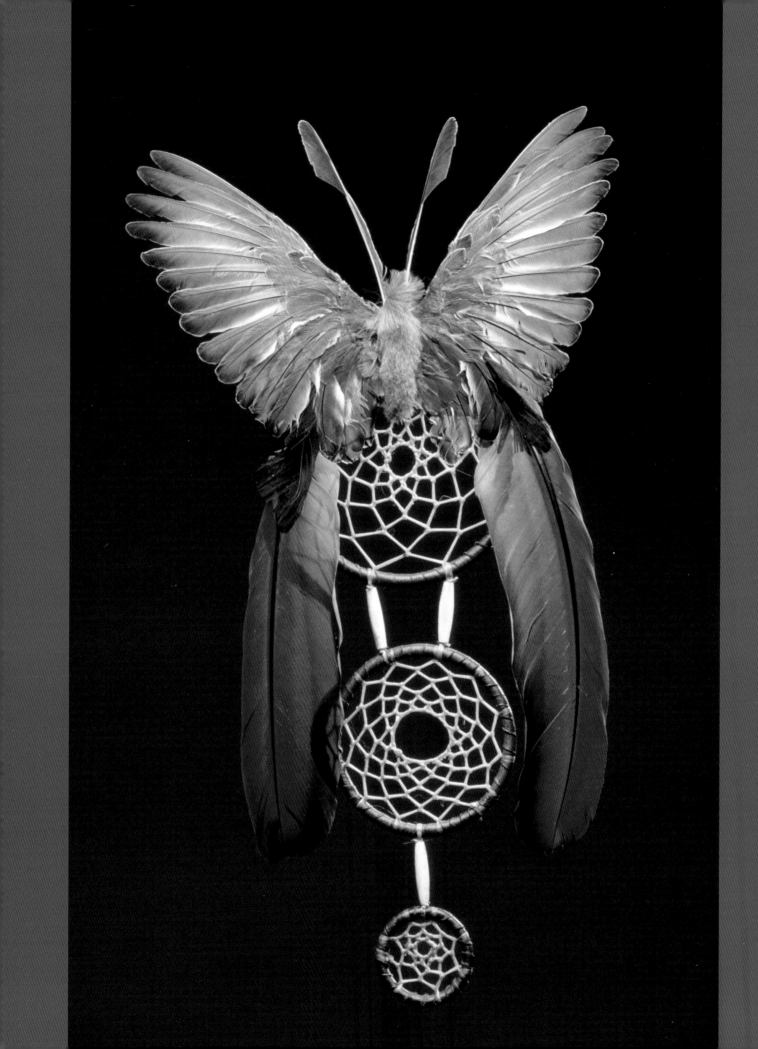

Legend and Distribution

The legend of the dream catcher began long ago, when the child of a Woodland chief fell ill. Unsettled by fever, the child was plagued with bad dreams and unable to sleep. In an attempt to heal him, the tribe's Medicine Woman created a device that would "catch" these bad dreams. Forming a circle with a slender willow branch, she filled the center with sinew, using a pattern borrowed from our brother the Spider, who weaves a web. This dream catcher was then hung over the bed of the child. Soon the fever broke, and the child slept peacefully.

It is said that at night, when dreams visit, they are caught in the dream catcher's web, and only the good dreams are able to find their way to the dreamer, filtering down through the feather. When the warmth of the morning sun arrives, it burns away the bad dreams that have been caught. The good dreams, now knowing the path, visit again on other nights.

FACING PAGE: *Butterfly* by Nick Huard. Photograph by Jan Thijs. Materials: Eastern bluebird wings, hyacinth macaw feathers, beaver fur, bone beads, caribou babiche.

PART ONE

Today, it's possible to purchase dream catchers at First Nations and Native American art centers, powwows, airport kiosks, museum gift shops, bargain stores and any number of other venues or gatherings. Across North America and beyond, wherever dream catchers are sold, some version of this story is printed and included with each item. Minor variations may occur — a Lakota Sioux dream catcher legend, for instance, claims the dream catcher traps good dreams and lets the bad ones pass through. With each, the promise offered by the dream catcher bears a direct relationship to the originating legend.

Composed primarily of circular hoops with weblike netting and often decorated with beads and feathers, dream catchers are recognized by Natives and non-Natives as a symbol of First Nations and Native American identity and spirituality. Produced in a range of sizes, from tiny examples less than one inch (2.5 cm) in diameter to some as large as eight feet (2.4 m), and occasionally even larger, dream catchers are also incorporated into jewelry and re-created as images on clothing and in art. Whatever the size or form of the dream catcher, bad dreams are intended to be caught in the net, while good dreams slip through to the dreamer.

What is it about dream catchers that makes them so compelling? What gives them power? Why do Native cultures imbue dreams with so much meaning? How is it possible that several First Nations can claim to be the originators of this form? What can we learn from both the distant past and the more recent traditional cultures? And why have dream catchers become so popular in today's society? Our dream is that this book will provide you with some answers to these questions.

In the 1990s, the commercial presence of dream catchers reached a peak in North America. A virtual flood of actual dream catchers — as jewelry and as imagery on everything from stationery, birthday cards and address stickers — began to appear in gift shops, tourist venues, craft outlets and at Native American gatherings. At the same time, newspapers and magazines overtly promoted dream catchers in feature articles and photographs or included them as more subtle aspects of the background.

Advertisements in Native American and museum gift catalogs, magazines

FACING PAGE: *Lynx* by Nick Huard. Photograph by Jan Thijs. Materials: Caribou antler, barn owl feathers, lynx skull, lynx tail, mink fur, horse mane, glass beads, turquoise, caribou babiche. OVERLEAF: *Elevation* by Nick Huard. Photograph by Jan Thijs. Materials: Great blue heron beak, snowy owl feathers, mountain ram skull, caribou babiche.

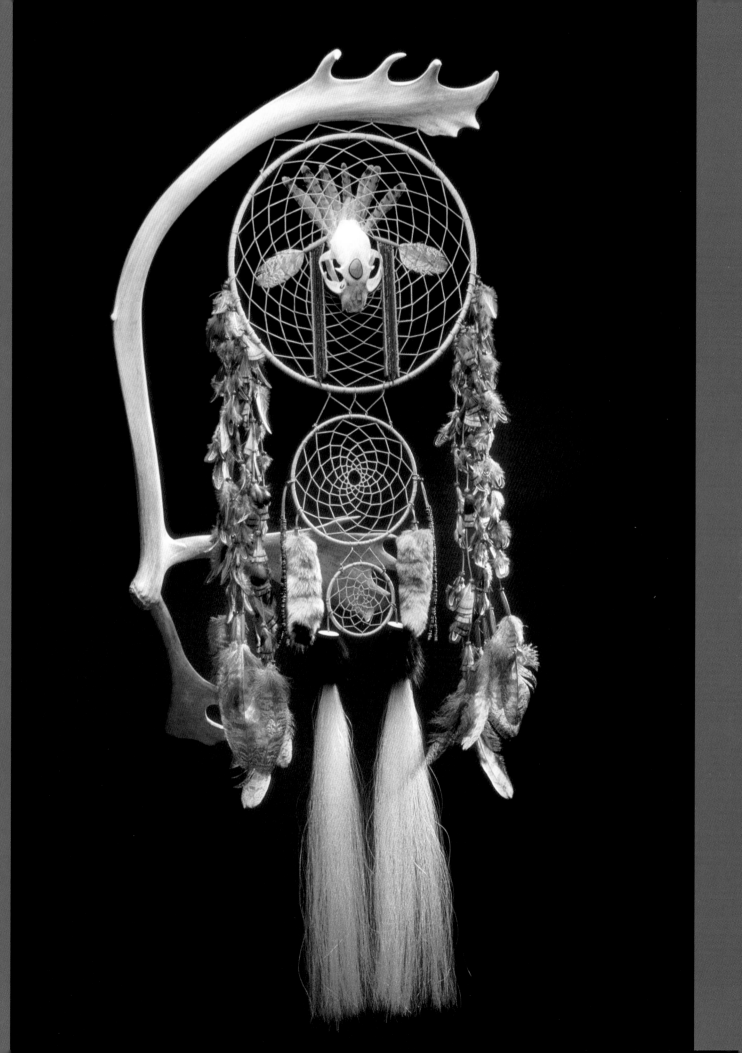

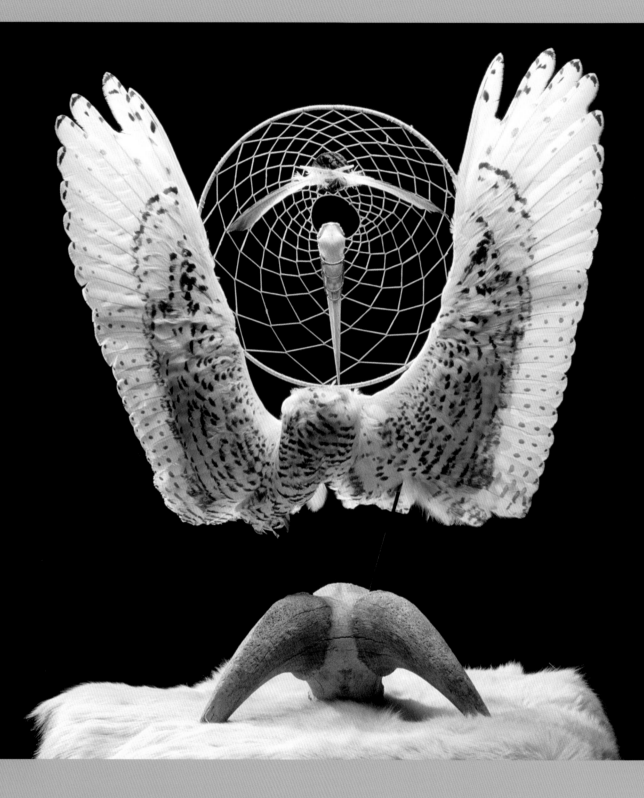

Categorized as tourist items by virtue of their presence and promotion in venues that attract tourists, dream catchers also now possess — embedded within their physical form — other layers of meaning.

and craft-supply catalogs offered ready-made Native dream catchers for purchase or in the form of craft kits that came with all the materials necessary to make your own. How-to instructions for making dream catchers and jewelry appeared in such Native-focused journals as *Whispering Wind* and on the Internet. Dream catcher imagery became incorporated into the artistic expressions of Native artists in two-dimensional and three-dimensional pieces, the form and style adapted to the content.

Using this evidence, it is possible to document the locations and tribal affiliations of the makers, from the Atlantic coast to the Pacific coast, from the subarctic to the American Southwest. Ethnic groups span the continent, including, for example, the Malecite, Mi'kmaq, Nanticoke, Penobscot and Passamaquoddy in the east; the Haida and Interior Salish on the west coast; the Haudenosaunee (Iroquois) and Ojibwa of the Great Lakes region; the James Bay Crees in the north; the western Crees, Blackfeet, Lakota and Dakota Sioux of the Plains; and the Navajo and Apache in the American Southwest.

Dream catchers meet all the requirements of the perfect souvenir purchase: they are small, portable, nonperishable, handcrafted and affordable. Categorized as tourist items by virtue of their presence and promotion in venues that attract tourists, dream catchers also now possess — embedded

RIGHT: Using a dream catcher motif, Anne Michell of the Nlaka'pamux (pronounced Ing-khla-kap-muh) First Nations of Lytton, British Columbia, where the Thompson and Fraser rivers meet, made these earrings in 1993. They serve as evidence of the rapid spread of dream catchers to other First Nations. Materials: Metal, glass beads, cloth, turquoise.

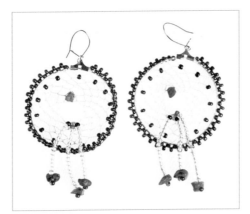

Most legends present a simulated and timeless mythical past
that projects a rather romantic essence to the Native culture.
One version stresses the Native belief that "dreams have magical qualities
with the ability to change or direct their path in Life."

within their physical form — other layers of meaning. They are considered functional in any number of situations. They can be worn as ornaments but are also employed as potential sources of well-being — to protect a vehicle operator, for instance, or to shield a computer from viruses. They may be used to filter messages or as a memento that validates a vacation.

It is their exoticism as material reminders of "the other" that renders dream catchers desirable as gifts and collectibles. It also appears that they may serve to signify and project — at least to the non-Native audience — the collector's empathy and presumed understanding of Native culture. Larger-scale art pieces, created as the consequence of dreams experienced by the artist and thus manifesting a further significance of creativity and mystical experience, reiterate the buyer's knowledge and appreciation of art, especially Native art. In these ways, dream catchers cross cultural boundaries and serve to communicate a shared consciousness that unites persons of different backgrounds.

While the wording varies only slightly between examples, the version of the legend or myth that accompanies each dream catcher introduces some appealing Native beliefs to the new owner. Most legends present a simulated and timeless mythical past that projects a romantic essence to the Native culture. One version stresses the Native belief that "dreams have magical qualities with the ability to change or direct their path in Life." Yet another states that "dreams are the messengers between the spirit world and everyday life. Bad dreams are caught in the dream catcher's web, and good dreams escape through the center to become reality." These optimistic

FACING PAGE: *Wolf Tale* by Nick Huard. Photograph by Pierre Dury. Materials: Wolf skull, caribou antlers with velvet, rabbit fur, horse mane, goose feathers, caribou babiche.
OVERLEAF: *Sun Dog* by Nick Huard. Photograph by Jan Thijs. Materials: Peary caribou fur, beaver fur, goose feathers, glass beads, caribou babiche.

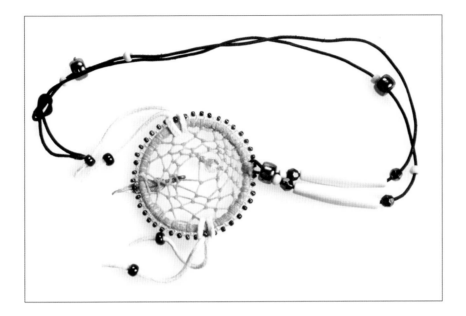

A dream catcher necklace made in 1993 by Anne Michell of the Nlaka'pamux of Lytton, British Columbia. Once this art form began to migrate across linguistic boundaries, from Algonquian-speaking peoples to speakers of Interior Salish, commodities such as this necklace and the earrings shown on page 13 began to be created specifically for sale. Materials: Leather, plastic, hide, cloth, metal, glass beads.

promises remain open-ended and can be interpreted in a number of ways. More overt is the attempt to create an intimacy between the maker and the buyer, who is assured: "With our warm hearts, we at the Pine Tree Native Centre of Brant, made this especially for you."

Another theme often emphasized in the maker's information is an awareness of environmental issues and current marketing ethics. In more traditional dream catchers, willow is used to form the circular frame and either animal sinew or vegetal fibers function as the netted interior. But contemporary makers frequently stress that while willow is still used for the hoop, imitation sinew and the feathers of nonendangered birds have replaced the earlier materials. These messages insist that only renewable resources have been used, implicitly reassuring animal rights activists that no animals suffered to provide sinew and, at the same time, addressing the concerns of naturalists, environmentalists and government officials who advocate against the wanton killing or mutilation of scarce avian breeding populations. Many craft kits and commercially made pieces substitute these materials with plastic or metal hoops

Working among the Ojibwa, anthropologists recorded the continued use of these netted charms. It has become evident, however, that the Crees — and, to a lesser extent, the neighboring Naskapi — also relied on netted charms as a protective force.

and synthetic sinew, yarn, wire, fine cord or embroidery floss. The artificial sinew developed from petroleum-based polypropylene can be split just like animal-derived sinew and is marketed as being ideal for dream catcher netting. Some hoops are wrapped with strips of hide or colored thread.

Items intended as jewelry are fashioned in gold, sterling silver and silver-colored metals. Decorative elements on many of these dream catchers include feathers, wool roving, tassels and beads of various origins. Smaller ones may feature tiny glass beads inspired by the dewdrops on spiderwebs and delicate feathers of metal. Regionally associated materials, such as sterling silver and turquoise from the American Southwest, are frequently used as decorative aspects in locally produced items. Feathers meant to assist the flight of good dreams are clearly labeled as those of chicken, turkey, pheasant or other nonendangered birds and are dyed and attached to the dream catchers. As well, individual artists often incorporate found items and traditional objects in their art pieces.

ORIGINS

Over time, a number of indigenous groups have laid claim to being the originators of the dream catcher. The more vocal among them have been the Navajo, Lakota Sioux, Huron, Crees, Mohawk, Cherokee, Iroquois and Ojibwa, even as other groups have been documented as producing them for use and for sale. In the first decade of the 21st century, however, many of these claims were put to rest by a consensus that identifies the Ojibwa as the originators. Let's take a closer look at the Ojibwa's traditional lifeways and material culture to understand how this general agreement was reached.

The Ojibwa are members of the broader Algonquian language family, which is widespread geographically and comprises many language divisions

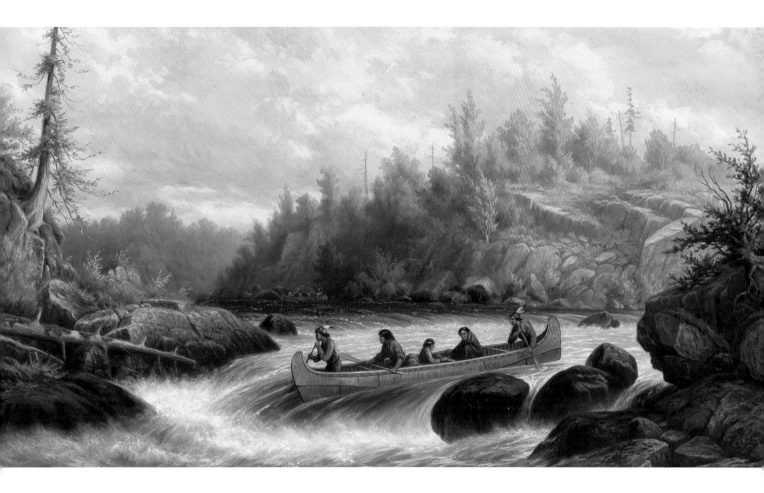

Ojibway Indians Shooting the Rapids, 1875; oil on canvas by Canadian artist Frederick Arthur Verner, 1836-1928. Inspired by his mentor, Paul Kane, Verner worked from sketches he had made during his 1873 visit to the Lake of the Woods and Rainy River area.

throughout its distribution. The more common languages include the Ojibwa, Potawatomi, Crees, Montagnais and Naskapi; the eastern groups, such as the Mi'kmaq, Malecite, Passamaquoddy, Penobscot, Abenaki and likely the now extinct Beothuk; Great Lakes groups such as the Delaware, Fox and Menomini; and western groups like the Blackfoot and Cheyenne.

In the mid-1800s, early travelers in North America began to make first-hand observations about the use of round, netted baby charms among the Ojibwa to protect their infants from colds, illness and evil spirits. Decades later, 20th-century anthropologists — anticipating the eventual absorption of Native cultures into the more homogeneous North American society —

undertook to gather information about indigenous groups. Working among the Ojibwa (known as Chippewa in the United States), anthropologists recorded the continued use of these netted charms. It has become evident, however, that the Crees — and, to a lesser extent, the neighboring Naskapi — also relied on netted charms as a protective force.

ALGONQUIAN CULTURES

Just as the Ojibwa and Crees spoke different languages derived from the Algonquian language base, each group eventually diverged slightly from the common hunting, trapping and fishing way of life their ancestors had shared. As each group responded to changes in its own habitat — sometimes the consequence of settling in different territories, perhaps as animal populations fell or rose — the means used to obtain the necessities of daily life began to evolve. Adapting to their surroundings meant learning a taste for novel foods, even as the technologies and strategies for procuring these resources had to be developed. While much of the mutual material culture and ideologies of the two groups remained unchanged, new practices were an inevitable reflection of their changing environments.

The Ojibwa, for example, inhabited the Georgian Bay and Lake Huron areas in the 1600s, according to European accounts. By the late 1700s, their territory extended from the eastern end of Lake Ontario, west to the Lake Winnipeg area in Manitoba and the Turtle Mountains of North Dakota and into southern Ontario. And they continue to live in the areas surrounding the Great Lakes today. According to Ojibwa traditions, they migrated, along with the Ottawa and Potawatomi tribes, from the Atlantic coast to the Great Lakes region about 500 years ago. They refer to themselves as Anishinaabeg, "the original people," or "human beings."

Prior to the arrival of Europeans, the Ojibwa followed a yearly cycle of hunting, trapping and fishing, in addition to collecting maple syrup, berries, nuts and medicinal herbs. By growing corn in the southern areas of their

FACING PAGE: Undated photograph of an Ojibwa woman holding her baby, securely laced onto a *tikanagan*, or cradle board. The board itself was probably made by the woman's husband or father, while the beautifully beaded cover with its floral design might have been crafted by the woman or her mother. When traveling, the mother carried the child on her back in the *tikanagan*.

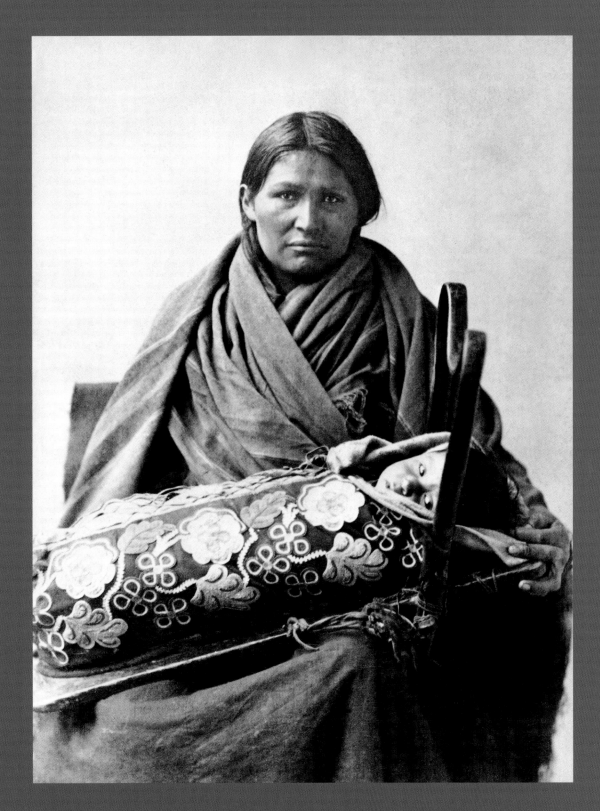

21

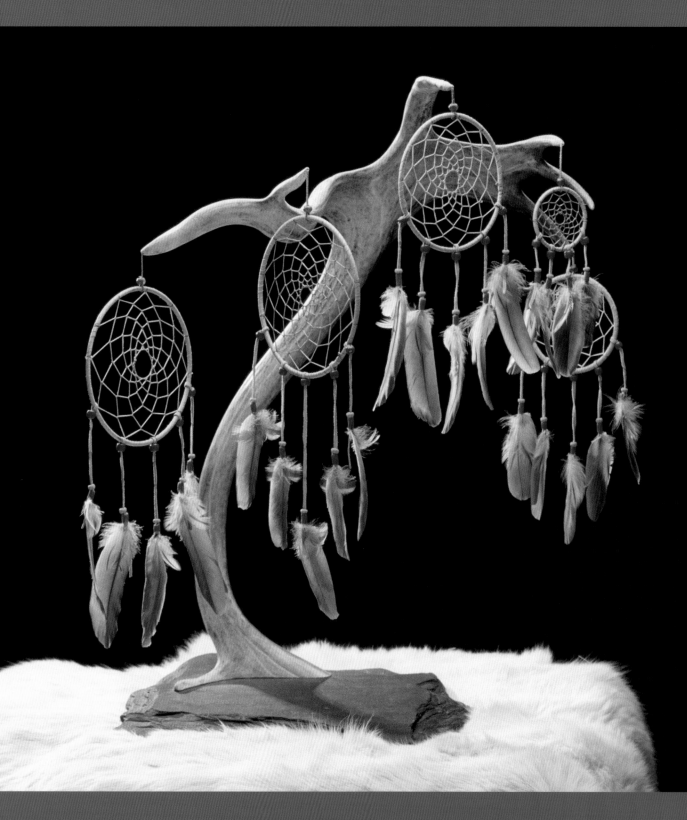

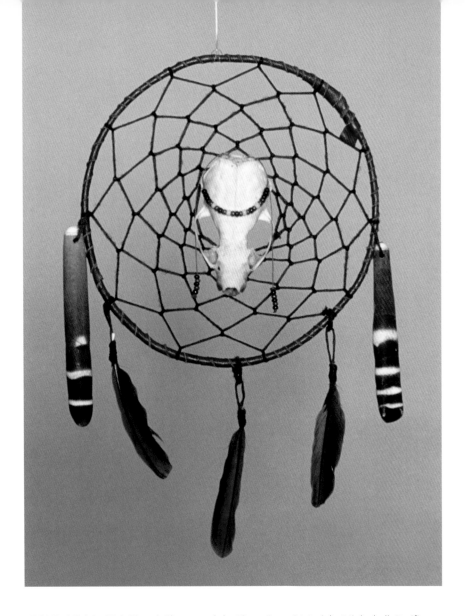

ABOVE: *Mink* by Nick Huard. Photograph by Pierre Dury. Materials: Mink skull, Pacific sea cucumbers, kingfisher feathers, glass beads, waxed linen webbing. FACING PAGE: *Dream Catcher Tree* by Nick Huard. Photograph by Jan Thijs. Materials: Caribou antler, goose feathers, glass beads, caribou babiche, slate.

territory and harvesting wild rice in the north, they increased their capacity to store food for the winter months. A seasonal cycle developed that allowed Native peoples to exploit each resource at the optimal time, returning year after year to the same locations. Late March found the Ojibwa collecting and processing maple syrup into sugar.

In the summer, when groups of Anishinaabe families gathered to collect berries and tend gardens, social exchanges took place. News was related, babies were welcomed, marriages arranged and elaborate ceremonies undertaken. At this time, White Dog Feasts, Drum Dances and the *midewiwin*, or

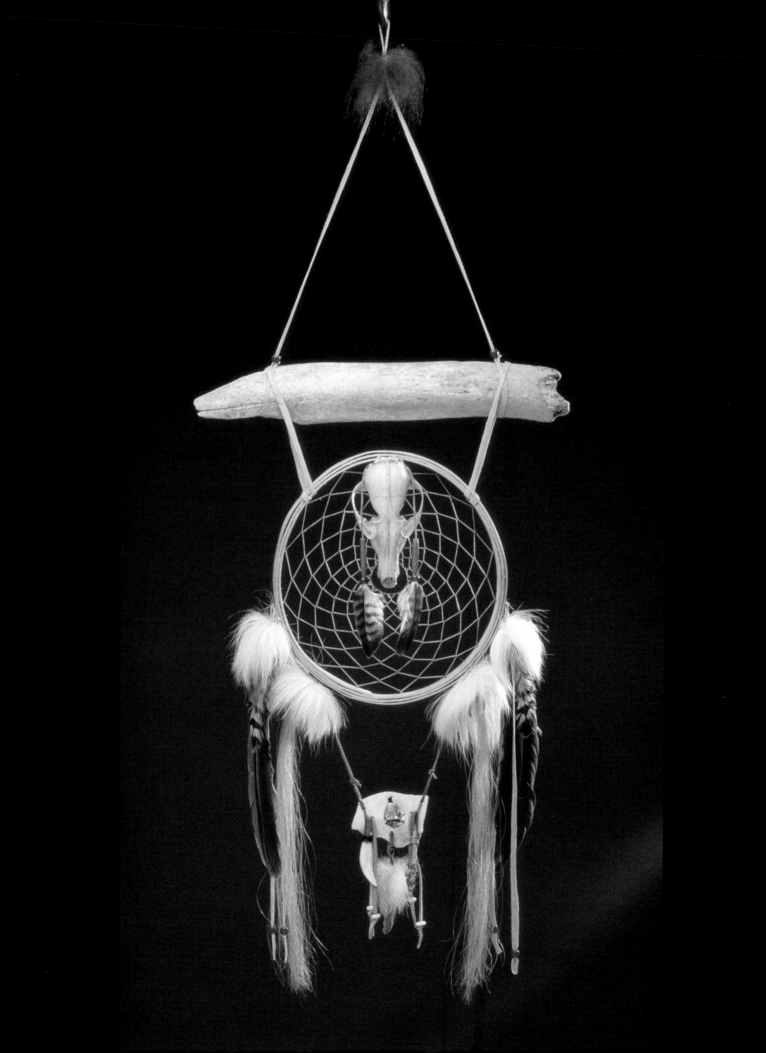

In addition to a common reverence for the sun, moon,
four winds, the thunderers and Grandfather Bear, which
they considered to be beneficent manitous, the Ojibwa and Crees
understood themselves to belong to a closely knit community of persons:
animal persons, human persons and other-than-human persons.

Grand Medicine Society, practices spiritually unified these usually widely dispersed groups. Once these reaffirming activities had occurred and wild rice was harvested and migrating waterfowl were hunted, small family groups headed to their winter hunting grounds, where deer, moose, beaver and other small fur-bearing animals provided sustenance and raw materials for clothing and building. Birch trees were used to construct their all-important canoes and their oval-shaped, round-topped wigwam homes.

The territory of the Crees is north of that of the Ojibwa, extending from Quebec, east of James Bay, across Northern Ontario, into northern Manitoba and westward, to the Plains. The Cree lifestyle reflects this more northerly climate. (Only in Northern Ontario have the two groups melded to form an Oji-Cree group, sharing a combined language and culture.)

For the most part, the subarctic climate impeded Cree efforts to garden, and diet items consisted almost entirely of meat, fish, fowl and berries. The primary meat source was traditionally caribou, as moose did not move into Cree territory until the early 1900s. Caribou, beaver, porcupine, the occasional bear, hare and other small fur-bearing animals were hunted and trapped for their meat and hides.

The Crees fished year-round, while the celebrated goose hunt took place each spring and fall, with the twice-yearly migration of the wildfowl to and from the south. Berries, collected and dried when ripe, were added to mixtures of dried meat and fat as a calorie-rich food source during the long, cold winter months. Like the Ojibwa, the Crees relied on birchbark for their

FACING PAGE: *Whale Rib* by Nick Huard. Photograph by Jan Thijs. Materials: Beluga whale rib, fox skull, Peary caribou fur, red-tailed hawk feathers, wolf tooth, seashell, glass beads, caribou babiche.

As welcome additions to the family, babies were swathed in moss and laced securely into bags and *tikanagans*, or cradle boards, until they were able to walk on their own. Everything in the community's power was called upon to protect this next generation of providers from harm and evil spirits.

canoes but often used caribou hides for their tepeelike homes, called *michuap*.

In addition to a common reverence for the sun, moon, four winds, the thunderers and Grandfather Bear, which the Ojibwa and Crees each considered to be beneficent manitous, both cultures understood themselves to belong to a closely knit community of persons: animal persons, human persons and other-than-human persons. (Communication among all the members of this community continues to be an accepted aspect of their lives. Respect must be shown to each member, often through the offering of gifts.) The hunting and killing of caribou, and especially bears, was marked by rituals denoting this respect. Hunters dressed in beautifully decorated clothing intended to please the animals so that the animals would "give themselves" to the hunters. Distribution of meat followed cultural patterns in which sharing and reciprocity were key elements for existence.

Clothing was fashioned from carefully prepared brain-tanned hides, stitched with sinew and decorated with pigments from the earth, dyed porcupine quills, plant and animal fibers and beads made from shells, bones or seedpods. Most equipment used to hunt, trap and fish was made from local materials that drew upon patterns carried in the collective memory of the Native peoples. Snowshoes and toboggans facilitated movement in winter, and canoes were the favored means of transportation the remainder of the year. Camp life focused on complementary roles: The women and girls were responsible for tasks in and around the camp, while the men and boys went off to hunt and trap food animals. Together, they survived.

As welcome additions to the family, babies were swathed in moss and laced securely into bags and *tikanagans*, or cradle boards, until they were able to walk on their own. Everything in the community's power was called upon to protect this next generation of providers from harm and evil spirits. One way to offer protection was by tying charms onto the hoop of the *tikanagan* or attaching them to the moss bags. While still laced into the *tikanagan*, the infant began a lifelong journey of learning through observation.

A Chippewa long-nose
birchbark canoe from Leech Lake,
Minnesota, circa 1850. Typical of the
canoes used by Lake of the Woods Ojibwa, this
canoe may have come to the Chippewa as a trade.

Then, as the child matured, the learning acquired from observing family members became reinforced through the successful completion of tasks. If, for example, a girl who was making moccasins made a mistake, she had to take out the stitching and resew them until her work met the approval of her mother or grandmother. Once a young girl was proficient in all aspects of sewing and decorating clothing, collecting wood, caring for infants, preparing food and maintaining the campsite and, in a similar way, a boy had gained the necessary expertise to make tools, hunt adeptly and follow the rituals associated with hunting, they were ready for marriage.

These traditional ways continued until well after the arrival of the Europeans. Eventually, the impact of the newcomers was experienced on two levels. First, Native efforts to hunt animals as a supply of meat and hides for clothing were refocused on procuring fine furs to exchange for European goods. Second, European missionaries encouraged Native peoples to surrender their customs to earn a place in the Christian heaven.

Despite these influences, many aspects of the Ojibwa and Cree cultural and spiritual belief systems were unaffected. Their three-part world of Sky, Earth and Underworld or Underwater remained populated with ancestors, Grandfather Bear, thunderbirds, underwater panthers, horned snakes, little people, tricksters, spiders and animal keepers, along with beneficial and malevolent spirits.

Young aboriginal children are encouraged to remember their dreams,
to talk about them and to try to analyze them.
It is believed that dreams contain knowledge of future hunting success,
and as such, the events often require some interpretation.

DREAMING

For both the traditional Ojibwa and Crees, the importance of dreaming, and the need to pay close attention to those dreams, is instilled at an early age. For them, dreams serve a twofold purpose: On one level, they help the dreamer to discern the location of game; on another, dreams act as portals for communication with supernatural persons.

The first type of dream experience — much like those we have all had — typically involves events that feature the dreamer as a participant. In contrast to our belief that dreams arise from within our own minds, Natives believe that dreams arise from the external world around the dreamer.

Young aboriginal children are encouraged to remember their dreams, to talk about them and to try to analyze them. Dreams contain knowledge of future hunting success, and as such, the events often require some interpretation. As a child matures, he or she is able to appreciate the arrival of dream visitors and to understand the power and sanctity of these interactions. Dream visitors come unbidden in dreams and are welcomed and venerated. Visions, on the other hand, are either actively sought or arrive involuntarily as the result of illness, stress or an unusual circumstance.

As a rite of passage, boys (and, in some groups, girls as well) are directed to solitary locations and, through sensory deprivation — lack of food, water, warmth, and so forth — open themselves to the possibility of experiencing a vision in which a guardian spirit will appear. (Please note that this is a very simplified explanation and does not delve into other aspects, such as age, the testing of courage and fortitude and the repetition or the acceptance or rejection of empowerment.)

FACING PAGE: *Egret by the Sea* by Nick Huard. Photograph by Pierre Dury. Materials: Guinea hen feathers, goose feathers, rabbit fur, egret skull, seashells, caribou babiche.

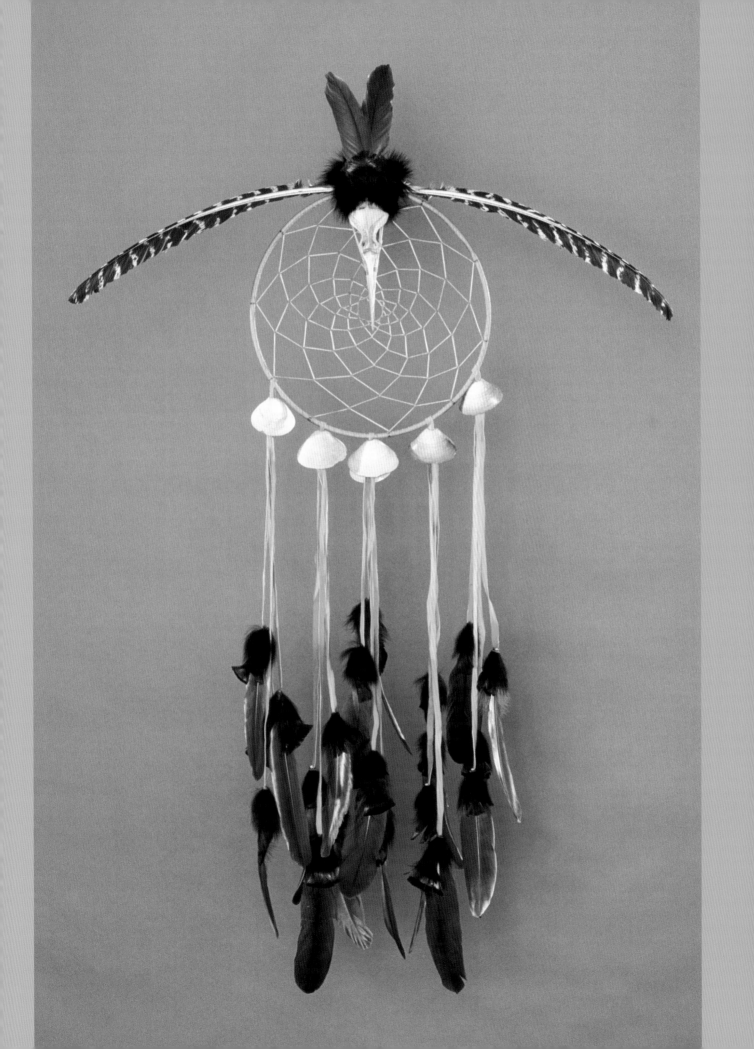

Because dreams are experienced by individuals,
the form and content of any communication with dream visitors
(or spirit helpers) are unique, although both the form and the messages
tend to fall within a culturally understandable pattern.

On a broad and generalized basis, we can accept that dreams and visions enhance the already considerable physical and spiritual powers possessed by peoples who form an intimate part of the physical world, members of the community of persons: human persons, animal persons and other-than-human persons. The key is that the spirits always choose the dreamer, never the reverse.

Several firsthand historical accounts provide insights into these experiences. After two decades of living and working with these Native peoples, early-19th-century fur trader George Nelson had become well versed in their system of spiritual beliefs and willingly listened with an open mind to what his Cree and Ojibwa associates told him. Drawing on conversations from his time at Lac la Ronge, Saskatchewan, in 1823, he provided these pertinent details with regard to the acquisition of guardian spirits: the solitude of the location, the nakedness of the dreamer, the absence of food and drink and the need for ongoing abstinence until the dreamer reaches a state in which the hoped-for "Dreamed" appears.

Nelson added that if the Ojibwa want to dream of the Spirits of the Sky World, their bed must be far above the ground, but if they wish to dream of the Spirits of the Earth World or the Water World, they must lie on the ground. What the Dreamed relayed to the dreamer was thought to foretell future events, and the dreamer had to follow the orders of the Dreamed.

More than a century later, the information given to anthropologist Regina Flannery in the 1930s by the Crees of the southern and eastern James Bay region echoes a similar understanding of and approach to dreaming. Whereas Flannery uses the Cree term *powatakan*, or dream visitors, the preparation and meaning were much the same. Because dreams are experienced by individuals, the form and content of any communication with dream visitors (or spirit helpers) are unique, although both the form and the messages tend to fall within a culturally understandable pattern.

The more often a person dreamed, the greater the number of spirit

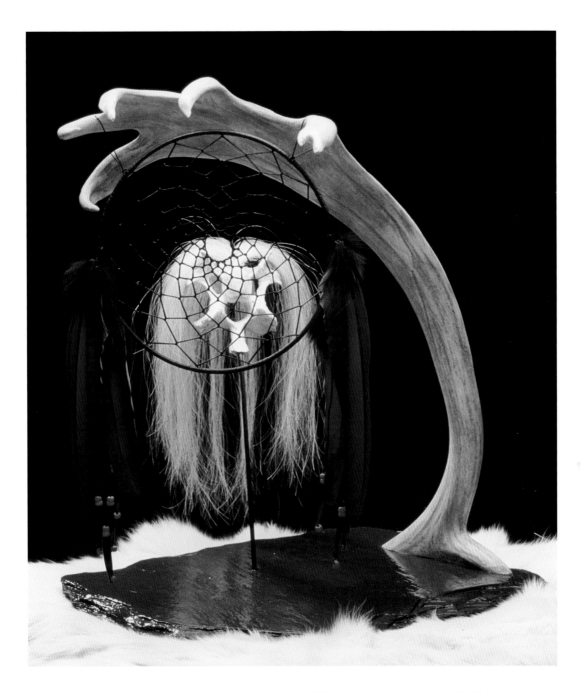

Flying Head by Nick Huard. Photograph by Jan Thijs. In Iroquoian mythology, the Flying Heads are a race of bodiless cannibal monsters with enormous heads and long, flowing hair or wings emanating from their cheeks. Materials: Caribou antler, moose vertebrae, horse mane, hyacinth macaw feathers, glass beads, waxed linen webbing, slate.

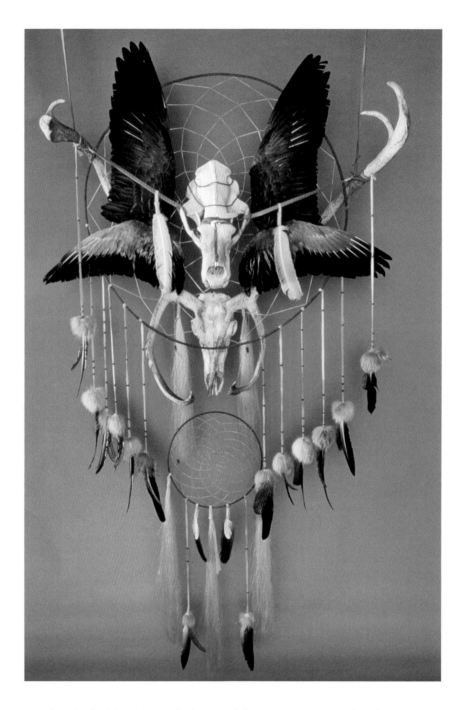

Nanuk and Tuktuk by Nick Huard. Photograph by Pierre Dury. Materials: Polar bear skull, caribou skull and rack, goose feathers, guinea hen feathers, Arctic wolf fur, glass beads, caribou babiche.

The Crees believed that everything a man used in hunting,
he had to dream first. The designs gifted by the dream visitors were relayed
to the dreamer's wife or mother, who would then render them
as a decorative style familiar to the group.

helpers and the greater the dreamer's spiritual power. Dream visitors not only informed the dreamer about animals but also gave him hunting songs, various kinds of hunting charms and the designs for the decoration of hunting clothing and equipment that would enhance the hunter's power to attract game animals. The Crees believed that everything a man used in hunting, he had to dream first. The designs gifted by the dream visitors were relayed to the dreamer's wife or mother, who would then render them as a decorative style familiar to the group. The more dream visitors a man had, the more elaborate the designs on his clothing. The intimate and precise meanings of such designs, however, were seldom revealed by the dreamer.

Some 70 years later, Cree elder Louis Bird described the dream quest of the Omushkegowak (the Swampy Crees of the west coast of James Bay and the southwest coast of Hudson Bay). He said that the first preparatory step is for a child to overcome the fear of being alone, particularly in the dark. With the guidance of his grandfather, the child must forgo such creature comforts as food and warm blankets. The child is told that once he has learned to control his fears and can gain a state of being half awake and half asleep, he can call or command almost any kind of dream that he wants. If the dreamer is afraid of a particular animal, he is instructed to call that animal into the dream in an effort to develop a friendship with it. The animal may then, in fact, become one of his spirit helpers. Other spirit helpers also come to the dreamer through these dreams.

Between 1930 and 1940, an Ojibwa chief, William Berens (1866-1947), had related similar stories to anthropologist A. Irving Hallowell. Ojibwa men rarely discussed the most vital part of their lives — the other-than-human persons they dreamed of during their puberty fasts. The *bawaaganag*, or dream visitors, who appeared to fasting boys had great powers to protect and help a man — or to hinder and hurt him. The boys sought the blessings of the dream visitors and hoped that they would become their guardian spirits. Once a dream visitor assumed that role, the young men could not talk lightly

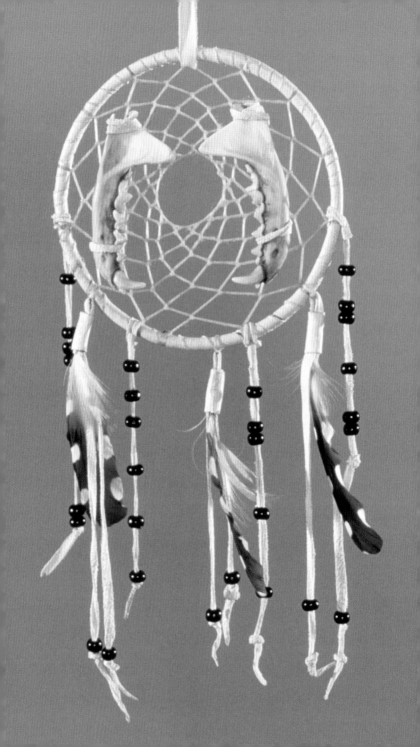

ABOVE: Image of the Ojibwa of Red River, Manitoba, from the June 4, 1870, issue of *The Illustrated London News*. The smoke visually separates two realities of Ojibwa life: waking and dreaming. Sacred smoke mediates between humans and the spirit world, carrying messages and blessings upward. FACING PAGE: *Mink Jaws* by Nick Huard. Photograph by Pierre Dury. Materials: Mink jaws, guinea hen feathers, glass beads, waxed linen webbing.

about these spirits for fear of offending them. Those who were blessed also had to be very careful to invoke their dream visitors only when truly needed.

Dreaming continues to be central to Native beliefs about spiritual power. Although dreaming and vision quests are undertaken by an individual, they are done for the benefit of the entire community. Clearly, this differs from the personal interpretations of dreams by non-Natives.

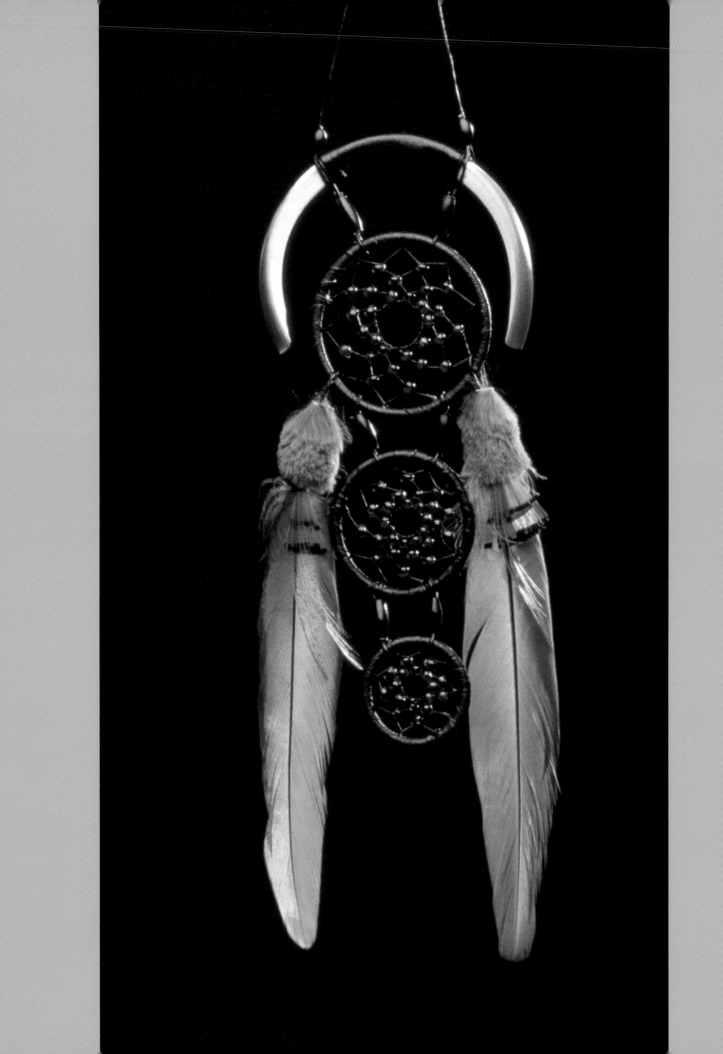

Net Charms

There's an important connection between particular indigenous peoples who practiced the hunting, trapping and harvesting way of life and the netted charms they made to protect their infants. Willow twigs bent and fastened to form a hollow circle from two to four inches (5-10 cm) in diameter were filled with netting of sinew or nettle twine, typically in a pattern that mimicked the design of a spiderweb. The finished charm was suspended from the arched hoop of the *tikanagan*, or cradle board, where it dangled in front of the baby's face. Alternatively, the charm would be attached to the moss bag that kept the baby snug or hung around the baby's neck, where it could rest on his or her chest.

The earliest documented mention of net baby charms among the Ojibwa of Lake Superior appeared in a work published by German ethnologist Johann Georg Kohl, in which he chronicles his 1855 visit to the region. In *Kitchi-Gami: Life Among the Lake Superior Ojibway*, Kohl describes the function of the charms as "good against illness."

Anthropologists conducting fieldwork decades later, in the 1920s and 1930s, likewise noted the presence of these charms. Among the Ojibwa of Parry Island in Georgian Bay, Canadian anthropologist Diamond Jenness described a baby's charm as a wooden hoop with a cross-lacing of string or thongs, observing that it was used to prevent colds and other maladies from reaching the baby, in much the same way that a spiderweb traps insects.

American anthropologists Sister Bernard Coleman and Frances Densmore each recorded the use of these charms among the Ojibwa in Minnesota as protective devices to safeguard a baby's soul or shadow. Densmore, in her

FACING PAGE: *Blue Beaver* by Nick Huard. Photograph by Jan Thijs. As we look up from the smallest hoop, these three dream catchers represent the past, the present and the future. Materials: Beaver teeth, glass beads, beaver fur, hyacinth macaw feathers, pheasant feathers, waxed linen webbing.

In earlier times, this netting was made from nettle fiber. Two spiderweb patterns were usually hung on the hoop, where they would "catch everything evil, as a spiderweb catches and holds everything that comes in contact with it."

general discussion about charms, noted that these protective devices, especially those with the spiderweb design, were hung on the hoop of the *tikanagan*. She observed that the charms consisted of wooden hoops about four inches (10 cm) in diameter filled in with a weblike design created with fine yarn which was usually dyed red.

In earlier times, this netting was made from nettle fiber. Two spiderweb patterns were usually hung on the hoop, where they would "catch everything evil, as a spiderweb catches and holds everything that comes in contact with it." American Regina Flannery noted in the 1930s that similar net baby charms were used to protect babies in the Spanish River area on the north shore of Lake Huron. Densmore suggested that the distribution of these charms was even more widespread when she made an unsubstantiated reference to like items having been found among the Pawnee in Oklahoma. Those charms, however, were said by the Pawnee to represent Spider Woman.

During this same period, net baby charms were documented among the Crees. English anthropologist Beatrice Blackwood collected a moss bag with a net charm attached from the Crees at Norway House in Manitoba. (This item was originally described by Blackwood as a net cradle charm used to protect an infant; unfortunately, the curatorial staff of the Pitt Rivers Museum, in Oxford, England, later changed her description to "dream catcher.")

The 1930s took Flannery to the James Bay area as well, where she spoke with women about childbirth and infancy, a conversation that male anthropologists at that time were unable to have. The Cree women told Flannery that to keep the baby from catching cold, a small ring of willow twig was filled with netting and tied onto the moss bag or suspended on a string

FACING PAGE: Spiders and spiderwebs have played an important role in Native life and mythology. With its sticky tensile strength, a spiderweb traps insects upon contact, thus serving both as a security system and as a source of food for the spider.

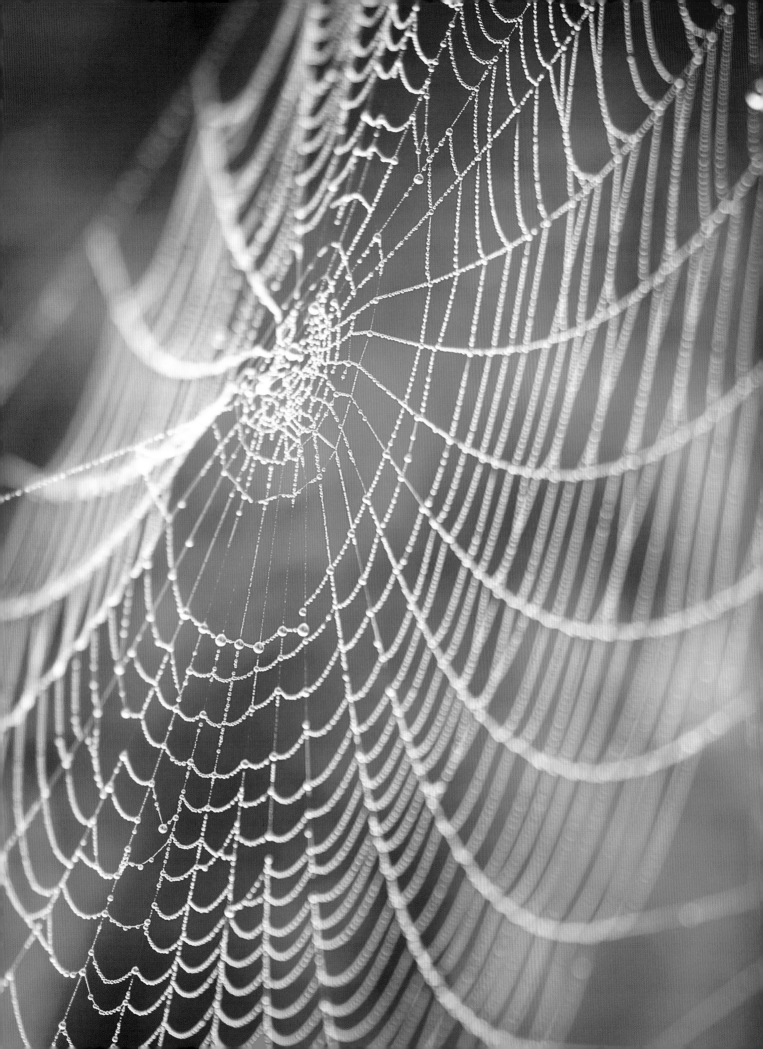

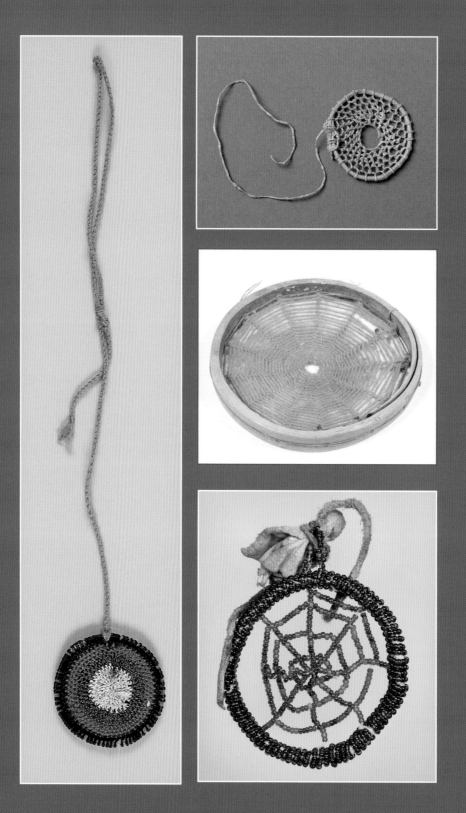

around the baby's neck. The net would then capture the cold (or evil spirit) before it could reach the child's chest. During his years as a teacher in the 1920s, British-born collector Sam Waller gathered three of these amulets in Moose Factory, Ontario, noting that they were used universally.

A handful of netted charms from the 1920s, 1960s and 1970s in North American museum collections broadens the geographic distribution somewhat. These charms also serve as evidence that materials less "traditional" than the wooden ring netted with indigenous materials were beginning to be introduced.

Two of the three Ojibwa examples in the American Museum of Natural History, in New York City, collected in 1920 in the Rainy River district of western Ontario, are made with glass beads and thread. The third, acquired in 1919 from the Minnesota Ojibwa, has a wooden hoop strung with red, green and purple yarn and string. Circular charms with spiderweb designs worked with colorful glass beads are in the collection of the Royal Alberta Museum, in Edmonton, Alberta.

Two net charms procured from the Crees at the Kawacatoose Reserve in Saskatchewan are beaded in the usual weblike pattern but are unusual in that each charm has a small piece of hide attached to an unidentified "power root," which may be analogous to the piece of devil's claw (*Fatsia horrida*) hung around the necks of children of the southern Yukon groups as amulets against illness. A third example is attached to a green velvet moss bag. Other Cree and Ojibwa museum pieces attest to the use of wooden, metal and plastic hoops netted with sinew, embroidery floss, woolen yarn, thread or string.

When Cree elders in the western James Bay communities and at Moose Factory were shown photographs of net cradle charms collected from Moose Factory in the 1920s and now housed in international museums, only a very few elders recognized them, and then only after much prompting. A couple

FACING PAGE: The variety of forms given to net baby charms is reflected in this collection. The charms were meant to protect a baby from bad spirits and illness, allowing the child to grow into a productive adult within the community. The circular hoops are made of wood or plastic and netted with one of the following materials: babiche (strips of rawhide), sinew, yarn, thread or beads. Some have central holes; others do not. Whether the charms were made by the Ojibwa in Ontario or Minnesota or by the Crees in Saskatchewan or Quebec or whether they were created in 1912 or 1966, the major defining feature is always the replication of a spiderweb. The power root fastened to a piece of hide and attached to the green beaded charm at bottom right is unique to Saskatchewan sources.

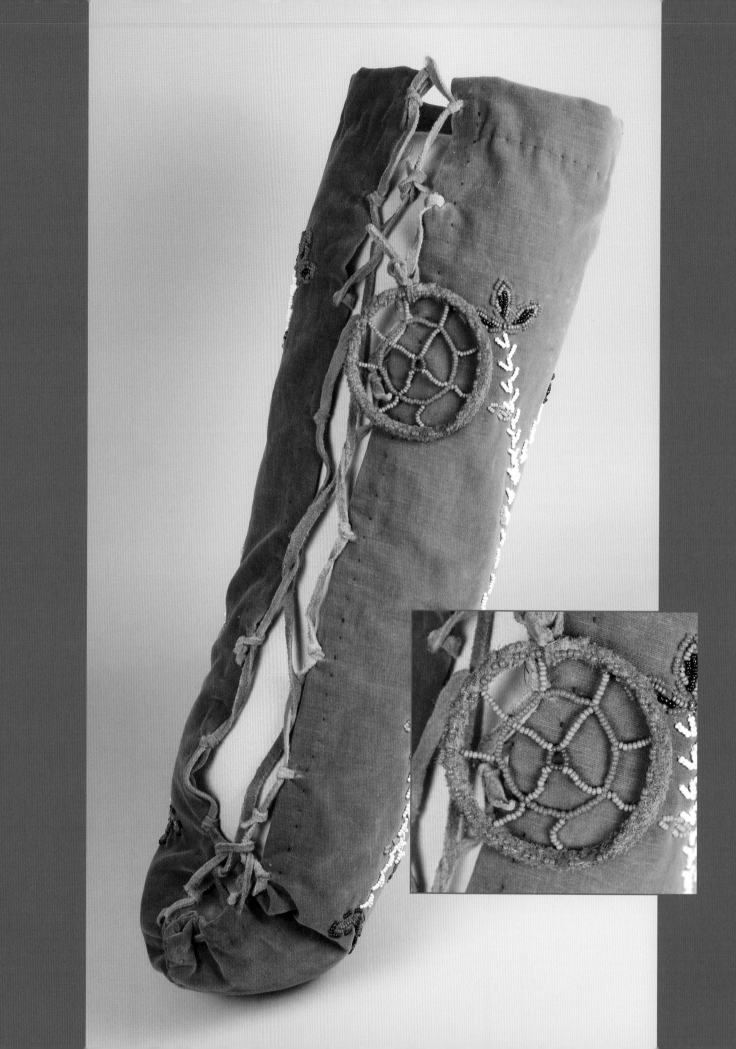

This gap in cultural memory is explained, in part,
by the revelation that the community had used another
form of charm for this same purpose.

of Cree women recalled making and using such charms for their own babies. At Waskaganish, on the east coast of James Bay, the charms were immediately recognized, but farther north, once again, the women did not recognize the items.

This gap in cultural memory is explained, in part, by the revelation that the community had used another form of charm for this same purpose. Miniature fishnets made from threads were tied around a baby's throat immediately after birth to ensnare colds, illness and bad spirits. This practice is corroborated by Cree author Jane Willis, from the northern Cree community of Chisasibi (once Fort George), who notes in her biography that her grandmother tied a black knotted thread around a baby's neck to ward off evil spirits. The baby was meant to wear the thread for the first few vulnerable months of life.

Among the Naskapi, the northeastern neighbors of the Crees, two distinct forms of beaded objects were used as protection for babies. The first is a beaded wristlet to ward off illness. The second is a *natutshikan*, or necklace, made for both the prevention and healing of maladies. Of the necklaces, only one can be used by young and old, male and female. It is plaited out of strips of skin (untanned caribou hide). As the Naskapi often blamed fish for disease, this netlike charm "caught" not fish but sickness.

This type of *natutshikan* is similar to the miniature fishnets of the northern Crees. The function of the net charms to catch colds, illness or anything evil is best understood within the context of the Native philosophy that saw children as cherished members of the community who would grow into healthy adults and contribute to the maintenance and well-being of that community. The idea of proactively protecting infants from anything that

FACING PAGE: This Nakoda Sioux beaded velveteen moss bag is adorned with a coordinating beaded net baby charm. Swathed in absorbent, biodegradable diaper moss, an infant is laced into the moss bag and laid in a hammock or placed in a *tikanagan*.

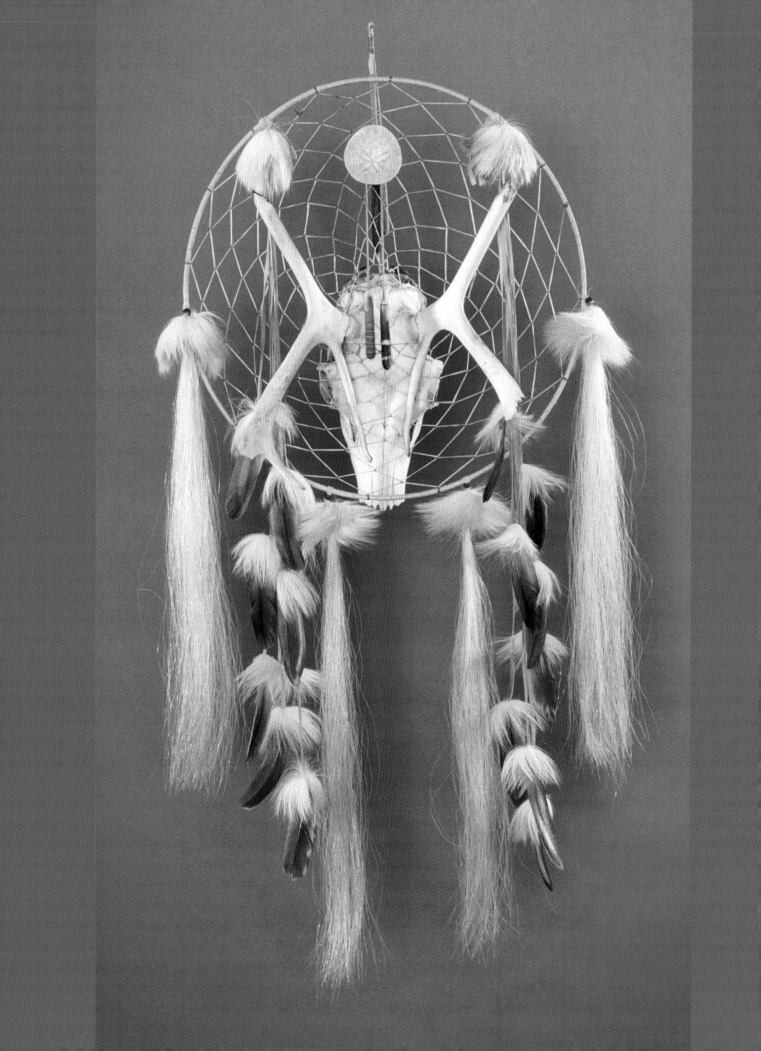

might cause them harm is perfectly consistent with that belief system. In the past, this belief system extended to the protection of the family when a family member died. For the first three days following a death, full-sized fishnets were sometimes spread around the Cree *michuap* (tepee), creating a netted barrier to prevent the spirit of the deceased from returning.

At one time, these charms were prevalent among the Ojibwa to the south and west and to the Crees and the Naskapi. Despite their different forms, the charms shared a single function: the protection of the young from evil spirits. Is there a rationale for their diverse forms? One explanation is revealed in the topography of the lands where the objects originated.

The Ojibwa and the Crees in the southern James Bay area radiated out across the land to follow traplines and maintain social networks. They are the makers of the circular charms. In contrast, the Crees of the northerly areas viewed their world from a more linear perspective; they followed the east-west water routes inland to their hunting grounds. They were the creators of the miniature fishnets. While differing ways of life help explain the distinct forms and materials, however, they do not explain the origin of the shared symbolic meaning of the net charms.

POWER IN LINES AND KNOTS

By figuratively untangling the netting component of both forms, the basic elements of the net charms can be reduced to lines and knots. Lines, in general, can be threads, cords, strings, straps and bonds and can be used to trap, ensnare, entangle, bind and, ultimately, link or connect tangible things. Intangible lines, such as traplines — in essence, a trail that the hunter carries in his memory — and those of kinship, also serve to link and connect. The power of lines is intrinsic to their linear form, but this power can be reversed by loosening or cutting the lines.

To reach a better understanding of the power of lines, consider the two major means of passing on cultural knowledge to the next generation of First Nations: material culture (that is, objects) and oral narrative, in the form of ancient stories and legends. These narratives feature lines as a mythical

FACING PAGE: *The Little Girl of Kanaaupscow* by Nick Huard. Photograph by Pierre Dury. Materials: Sand dollar, caribou skull and antlers, Peary caribou fur, horse mane, goose feathers, caribou babiche.

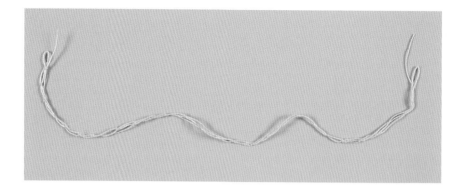

ABOVE: When shown examples of circular net baby charms, contemporary northern women on the east side of James Bay did not recognize them. But further investigation revealed a memory of a like artifact: a miniature fishnet tied around an infant's throat at birth and meant to function in an identical protective manner as the charms from the south. Just as fishnets are used to catch fish, these miniature nets were thought to catch disease and evil spirits. FACING PAGE: *Festival of the Wolf* by Nick Huard. Photograph by Pierre Dury. Materials: Branch of black ash, caribou antler, beaver skull, wolf skull, beaver teeth, fur, red-tailed hawk feathers, abalone shells, caribou babiche.

motif. Numerous variants of one particular myth occur in both Cree and Ojibwa legends. The essential story unfolds in this way: The Cree hero Tcikapis (Chahkapes to the Ojibwa) and his sister live together after the death of their parents, who have been consumed by giants in either human or animal form. One day, Tcikapis finds a path and wonders whose path it might be. To discover the answer, he obtains a line (variously a hair or a thread) from his sister. With this line, he fashions a snare.

In the morning, everything is in total darkness, and Tcikapis realizes, too late, that the path was that of the sun, and it is the sun he has snared. He attempts to loosen the snare to release the sun but fails. Eventually, a tiny creature (variously a mole, mouse, shrew or beaver) manages to get close enough to the sun to successfully gnaw through the restraint. This version focuses on the snaring and releasing of lines, which is repeated again and again in a hunting, trapping and fishing society. It also links the Sky World, with its sun, and the Earth World, with its gnawing creatures whose intimate association with the Earth is established through underground trails and interconnected tunnels or, as with the beaver, through the water channels created in the marsh from tree source to the beaver's lodge.

In another story, Tcikapis catches two beaver and ties them up with the

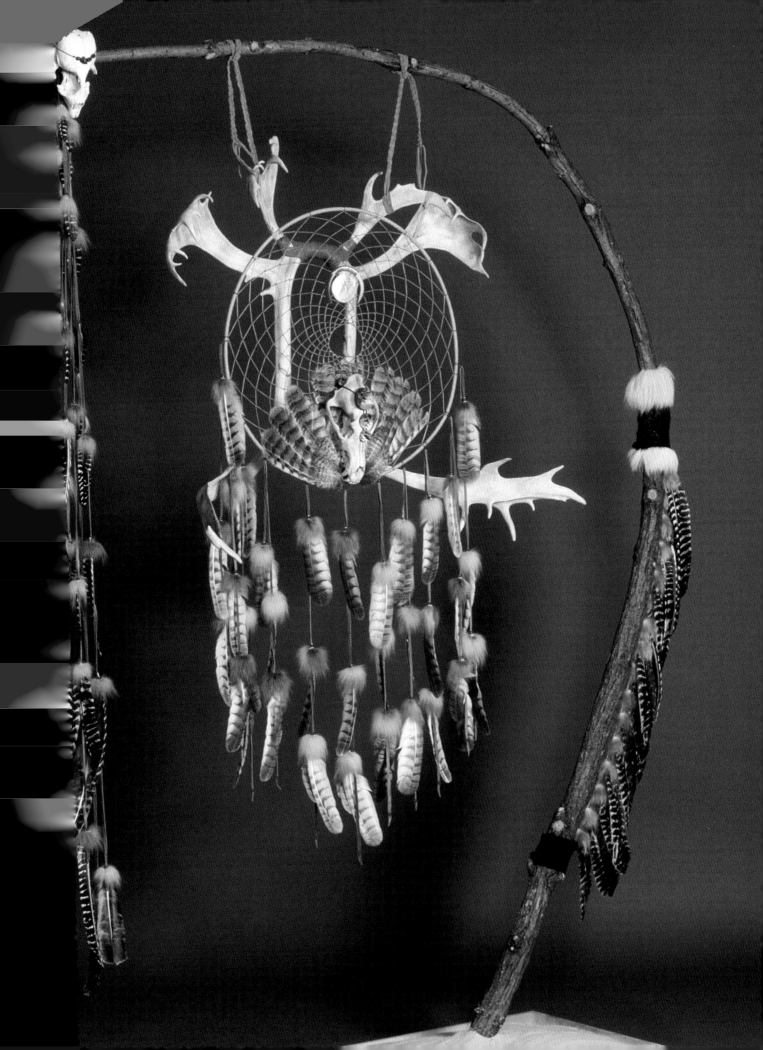

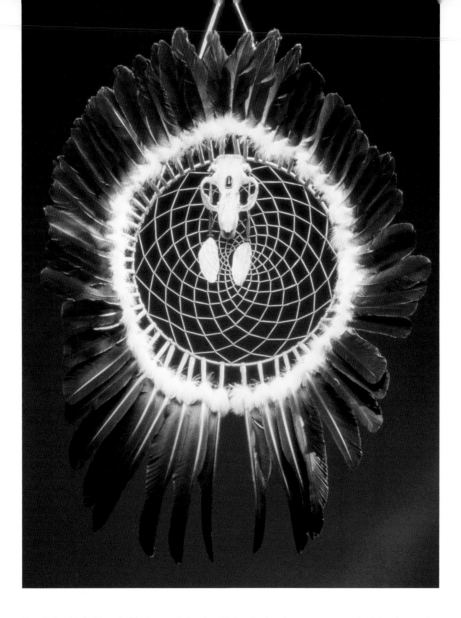

Bustle by Nick Huard. Photograph by Jan Thijs. A circular arrangement of feathers, the bustle is worn on the lower back as part of the powwow dance outfits. Traditional dancers favor a single bustle, while Fancy dancers use twin bustles. Some dancers also add dream catchers to their bustles. Materials: Beaver skull; tigereye, goose feathers, seashells, deer hide, caribou babiche.

string from his bow. Giants from the Earth World demand that he give them one beaver. He agrees, but only on the condition that they can untie his string. Unable to loosen the tie, the giants leave empty-handed.

While this tale is cosmologically important, with beaver mediating between the Earth World and the Water (or Underwater) World, it is the power of the line that is significant. A comparable circumstance in real life occurs when a Cree hunter slays a bear and places his *nimaapaan*, or carrying string, on the bear's chest. When the hunter leaves the bear to go for assis-

In Ojibwa narratives, Spider is responsible for keeping
the community's food from spoiling by trapping decay-producing
flies in its web and thus protecting the provisions.

tance, the string "fastens" the bear, and the power of the line protects it from
malevolent spirits until the hunter returns with helpers.

The connection also involves the mythic arrival of the first Cree couple
on Earth, who descend from the Sky World in a cobweblike bag suspended
on a line spun by the Great Net-Maker, or Spider. Admonished never to
look down at the same time, the couple are so excited about what they are
seeing that they gaze down simultaneously. Their net bag becomes snagged
on the Thunderbird's nest, high in a tree. As in the creation myths of other
groups, various animals attempt to rescue them, and in so doing, each reveals
the characteristics with which humans associate them.

The first to arrive is the Caribou, who explains that his hooves prevent
him from climbing. Then the Lynx appears, but his statement that he never
climbs is considered to be an untruth, because he has a reputation for lying.
Eventually, the Bear arrives. Using his strong claws, he climbs the tree and
carries the two down to Earth. The wise Bear becomes the mentor to this
first couple and teaches them all they need to know.

Clearly, it is the netted appearance of this container woven by Spider
that resonates with the physical descriptions of the net baby charms and,
ultimately, the dream catchers. Spider's thread connects the Sky World and
the Earth World, the spiritual reality with the physical reality.

In Ojibwa narratives, Spider is responsible for keeping the community's
food from spoiling by trapping decay-producing flies in its web and thus
protecting the provisions. It is Spider's expertise at making nets that forms
the basis for the following Ojibwa tale. One of Johann Georg Kohl's stories
about the Ojibwa of Lake Superior concerned the ongoing battle between
Nana'b'oozoo (Naanabozho; Nanabush), the trickster who was half human
and half manitou (that is, an other-than-human person), and Mishipizhiw,
the water monster variously interpreted as an underwater panther or a
horned serpent.

Nana'b'oozoo had shot his arrows and injured Mishipizhiw and three
of his snake sons. On the advice of the turtles, the snakes retaliate by making

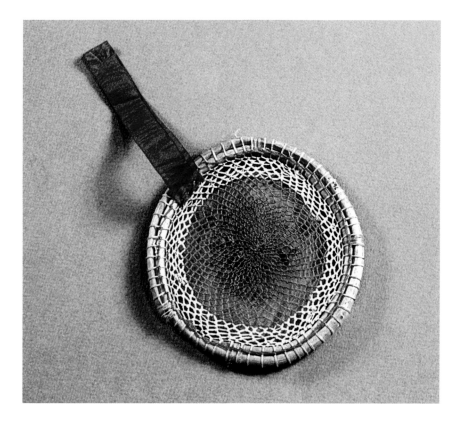

ABOVE: The round stick frame of this Cree net charm is completely filled in with an open-mesh netting of silk embroidery floss. The charm was a gift to anthropologist Dr. John Cooper in 1934 by Harriet Whiskeychan of Rupert House (now Waskaganish), on the Quebec side of James Bay. According to Mrs. Whiskeychan, it was "used to ward off colds from a baby." FACING PAGE: *Wolf No. 2* by Nick Huard. Photograph by Pierre Dury. Materials: Arctic wolf skull, caribou antlers, caribou fur, goose feathers, glass beads, caribou babiche.

a magic net to cover the entire Earth. The key to the tale, of course, is that the ropes for this net are spun as fine as spiderwebs so that Nana'b'oozoo will not become suspicious. The hope is that the trickster will become entangled in the net, and the snakes will then cause the water to rise and drown him, thereby eliminating their enemy. Once again, however, Nana'b'oozoo outwits them, and the scheme fails.

As an intermediary phase between this myth's verbal imagery and the visual imagery of tangible material culture, the string games that are played in virtually all cultures provide an insight into the intricate manipulation of string into myriad figures. Some of the figures may be abstract; others may

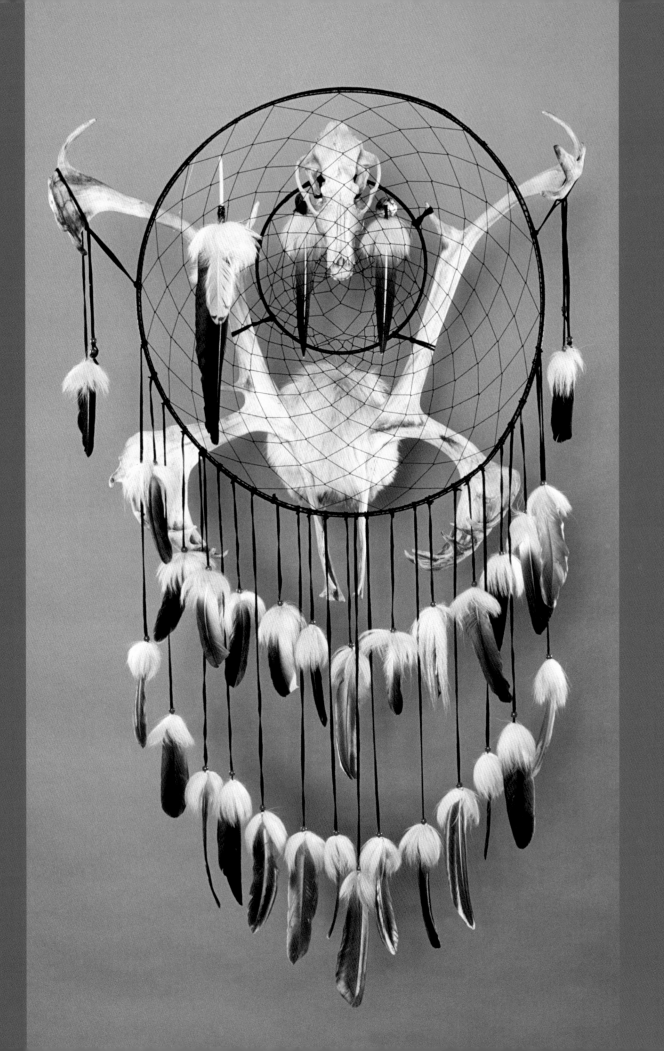

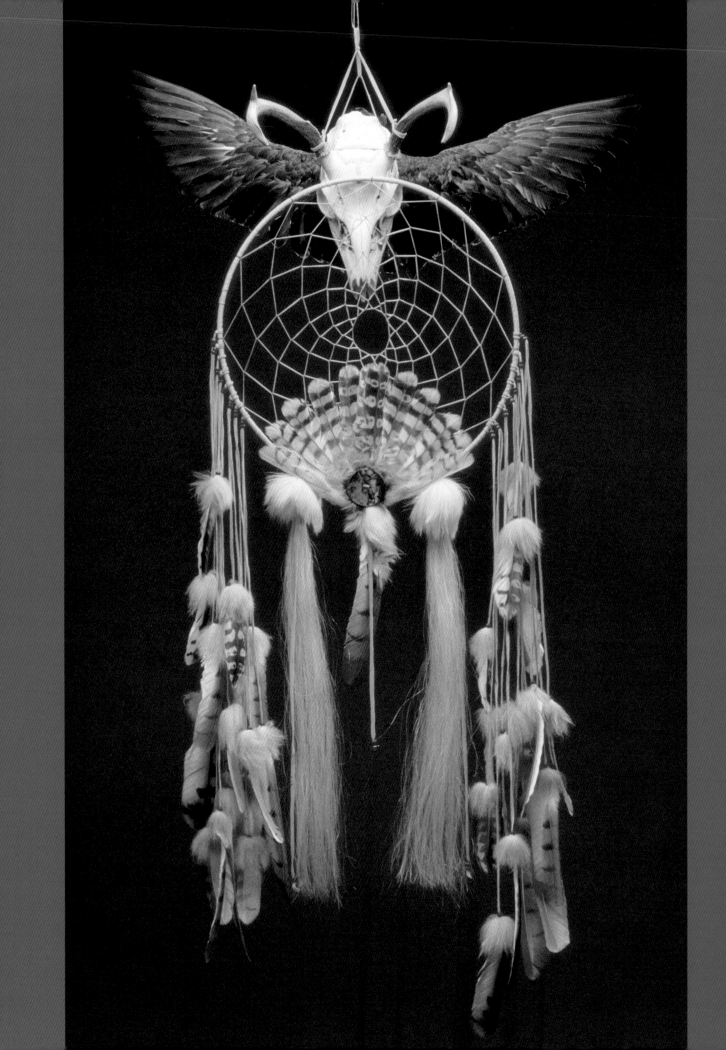

The use of lines in most Native cultures, especially the Crees, is significant.
A particularly relevant example is the Cree hunter's *nimaapaan,*
a ceremonial carrying string used to drag home game. Plaited from strips
of caribou hide, this string is initially made by the young hunter's mother.

be viewed as animals snared in real life or as heavenly bodies. Most are given names. Cat's cradle is one such game.

In the past, string games among the Crees and the Ojibwa were played only in the winter, a time coincident with the telling of sacred myths. This custom may parallel known Inuit beliefs and practices in which playing string games during periods of sunlight is prohibited for fear of snaring the sun and precipitating darkness. Given Tcikapis's experience of doing just that, this is a reasonable explanation.

The use of lines in most Native cultures, especially the Crees, is significant. A particularly relevant example is the Cree hunter's *nimaapaan,* a ceremonial carrying string used to drag home game. Plaited from strips of caribou hide, this string is initially made by the young hunter's mother. Encased in its own pouch so that it doesn't frighten away the animals, it is included in the boy's miniature game bag along with other hunting paraphernalia when he leaves the *tikanagan* to take his place in Cree society.

As the young man develops hunting prowess, his mother, and later his wife, makes him increasingly longer carrying strings. Full-sized *nimaapaans* are utilized by the men all year, but it is in winter that the carrying strings' characteristics become most evident. When beaver are caught in the winter, they are ritually entrapped with the *nimaapaan* and dragged home over the snow. This manner of transporting the beaver creates a trail or path — a visual connection between the beaver, its home and family and the hunter and his home and family. It replicates the trails through the bush that link one Cree hunting camp to another, one family to another.

Somewhat more indirectly, the trail refers to the imagined kinship ties

FACING PAGE: *Spike* by Nick Huard. Photograph by Jan Thijs. Materials: Arctic wolf skull, caribou antlers, goose feathers, red-tailed hawk feathers, horse mane, Peary caribou fur, abalone shell, glass beads, caribou babiche.

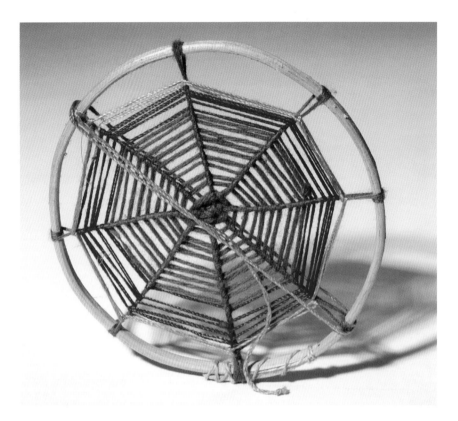

ABOVE AND FACING PAGE: American anthropologist Frances Densmore collected these three Ojibwa spiderweb charms in 1919 and 1920. The charm above, from Minnesota, is strung with commercial yarn and is the most weblike of the three. The beaded examples on the right, from Manitou Falls in Ontario's Rainy River region, are the first known charms to utilize glass beads for the netting. Although the charms are strung in a weblike fashion, the spiderweb effect is not as obvious. Despite the use of different materials, however, the intended function — to protect infants — remains the same.

between humans and beaver created by a man's mythological marriage to a beaver wife. In real life, the slain beaver is presented to the hunter's wife, who welcomes it into their home. As the hunter waits outside, she proceeds to skin the beaver and prepare the meat to sustain the human family.

When we consider the material forms in which netting appears, whether as a physical element in an object or as a decorative device painted onto an object, the depth of meaning that lines and netting hold for Algonquian-speakers begins to reveal itself. The process of transforming lines of sinew, thread, string or hide thong into knotted and netted objects is carried out

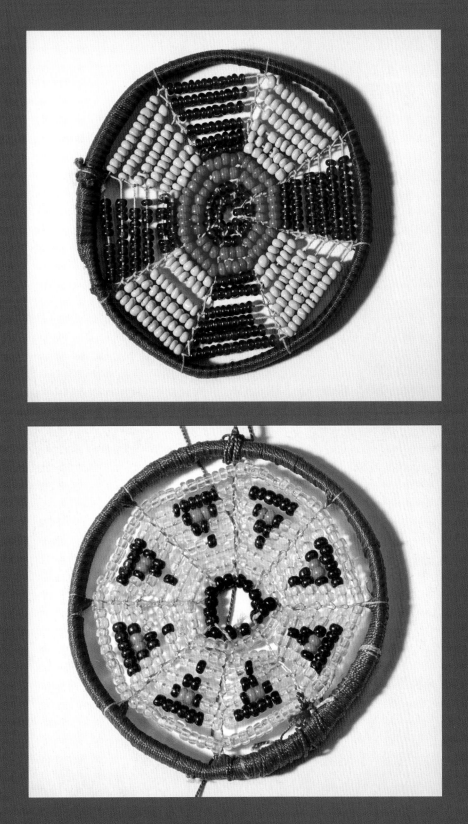

On a less tangible basis, the Algonquian expression
"From great-grandparents to great-grandchildren, we are only knots in a string"
carries within it the concept of kinship, the continuation
and connections of one generation with another and the lineage
and means for transferring cultural knowledge.

by the women. Just as Tcikapis's sister provided the hair or thread for the mythological snare used to trap the sun, it is women who braid the hunters' carrying strings and the net maple syrup skinners, make fishnets and beaver nets, bead netted necklaces, lace babies into moss bags and *tikanagans*, stitch together clothing, birchbark containers and canoes, fashion the all-important net bags they use to transport household goods, knit rabbit-skin clothing and blankets and, of course, create net baby charms.

In the past, women also painted the two-dimensional netting (or crosshatching) patterns on caribou-hide coats and the net designs on the front of toboggans to protect against evil forces and ensure successful hunting. (Given the sacredness of birchbark scrolls, it is presumed that it was the men who so carefully scored the lines of crosshatching on the figures that appear on these scrolls.)

This striving for protection and provision underscores the complementary roles of Native men and women, which is exemplified in northern areas through the making of snowshoes. The man procures the wood and constructs the frames, while the woman makes the netting and creates the protective design. This joint effort produces an effective means of transportation that protects the wearer (man or woman) from both unseen malevolent forces rising out of the ground and potential starvation. Their shared labor ensures their survival through the winter and their ability to maintain contact with their community.

On a less tangible basis, the Algonquian expression "From great-grandparents to great-grandchildren, we are only knots in a string" carries within it the concept of kinship, the continuation and connections of one generation with another and the lineage and means for transferring cultural knowledge. The term "to tie the knot" indicates that a Cree man has a great-grandchild and all that this implies. For cultures that learn through observation, Spider's role as an instructor in both creating netted items and providing guidelines

56

on their manufacture follows a similar concept and reinforces the service of nets as protective devices and as a means of removing unwanted elements in life. Tying strings or lines into knots and nets is effectively adding a deeper level of symbolism; certainly, interpretations derived from examination of similar objects in other cultures support this.

NON-ALGONQUIAN CULTURES

As seen in the Cree and Ojibwa cultures, nets appear to have somewhat contradictory or paradoxical functions. The act of snaring and trapping fish, bears and other game connotes a negative aspect that is understood to be counterbalanced by the release of the animal's spirit and the provision of food for humans. So, too, the entanglement of illness and bad spirits in nets provides a positive function of protection, not just for infants but also, by extension, for the entire community.

The visual and verbal imagery from other time periods and regions helps form a comparative framework. This imagery establishes that one dominant personage in the myths of other North American and Mesoamerican groups, identified as the Net-Maker, or "the one whose thread never runs out," is referred to as Grandmother Spider or Spider Woman. Spider Woman's web-making and netting skills become teaching examples for human artisans to replicate. But the significance of these netted products rests in their functions.

One of the earliest pieces of evidence of spiders and webs uncovered in the western hemisphere dates to AD 100 in Peru. Here, the archaeological remains of an ancient Moche lord were found; he had been buried wearing a necklace comprising several gold circular spiderwebs, complete with spiders. Scholars of these Moche remains now indicate that the representations refer to the Spider in its role as decapitator, but an argument can also be made that through decapitation and subsequent death, the decapitator is protecting the culture from unwanted or evil elements.

This concept of protection appears again as our focus moves farther north, to the cultures of pre-Hispanic Mesoamerica. The richness of imagery illustrated on stelae (incised upright stones), painted vases, murals and codices (books) of the Maya, Teotihuacano and Aztecs is most relevant toward the development of netted hoops and dream catchers. On these Mesoamerican items, depictions of the Spider Woman deity reveal a strong correlation between spiders, webs, nets and snares and women, creation, water and scry-

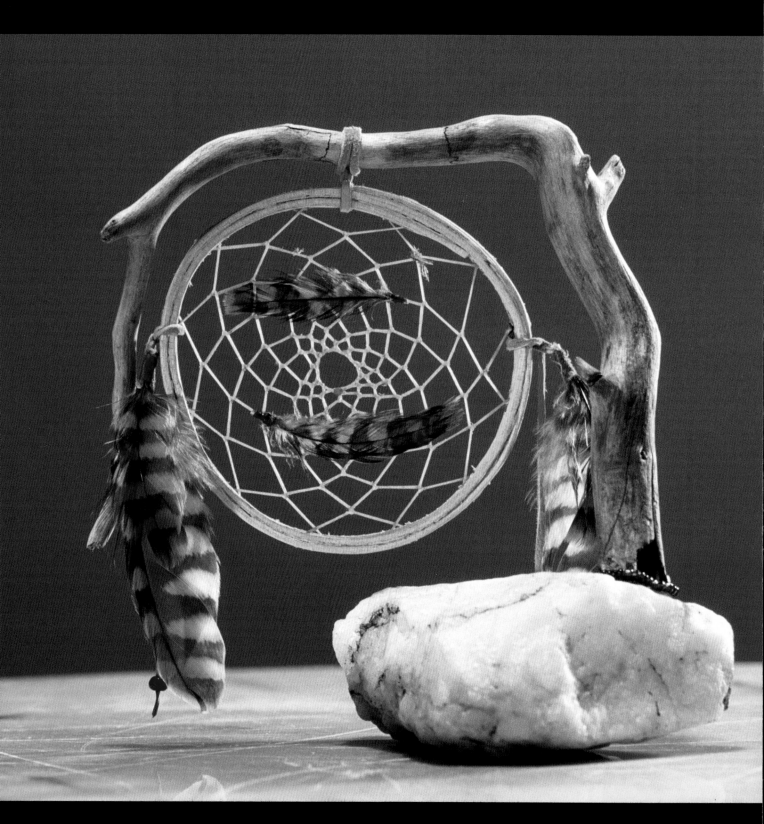

Entrapment technology was also adopted to punish humans who had sinned in some manner. For example, a murderer's punishment was death by snares.

ing — a form of divination that interprets the reflections or images in a bowl of water or in a mirror. Aztec images of insects with netted circular abdomens were intended to catch and remove illness, an interpretation more closely linked to circular net baby charms and dream catchers.

The positive aspect of these associations, however, is countered by the use of cords, nets and snares as symbols of entrapment, sin and punishment. Entrapment derives from Mesoamerican hunting technology, which involves the extensive use of these items to catch fish and game. In particular, snares set along paths frequented by game were utilized to capture deer, while nets were used to catch both birds and fish.

Entrapment technology was also adopted to punish humans who had sinned in some manner. For example, a murderer's punishment was death by snares. Other crimes warranted death by garroting or being squeezed in a net. The use of snares and nets to punish — in effect, to remove undesirable sinners — reflects their function as a mechanism for maintaining social order and as a means of protecting the good from undesirable people and situations. As Spider Woman was also associated with matters of war, it is tempting to consider the woven shields depicted on her clothing as another form of protection.

Echoing these earlier images, the Huichol of contemporary Mexico continue to use the traditional circular *neali'ka*, or netted shield. According to Huichol narratives, the first *neali'ka* was a spiderweb woven over a votive bowl associated with the rain. Historically, there were the two circular forms of *neali'ka*, each created using a different technique. One was formed by interweaving thread around radiating splints to resemble a round spiderweb. The other was simply a small wooden hoop containing a loosely woven string net. Some nets enclose a mirror at the center; others leave the center open. As

FACING PAGE: *LG3* by Nick Huard. Photograph by Pierre Dury. Materials: Driftwood, redtailed hawk feathers, spruce hoop, caribou babiche, quartz.

Consideration, too, must be given to Pueblo accounts of creation,
in which linear movement from one cosmological world
into the next necessitates climbing up through a hole in the ground —
often aided by Spider — to the next world above.

with the Zuni water shield of the American Southwest, the *neali'ka* is made from a continuous cord that is twisted rather than knotted. While the *neali'ka* is now offered in prayer to the Huichol's ancestors and as a portal to the other realms of the cosmos, its earlier meanings have been gradually lost.

As we move from Mexico to the American Southwest, we find a vast body of mythology augmented by visual representations resplendent with images of hair, spiderwebs and netted shields that associate Grandmother Spider with creation, war and future vision. Consideration, too, must be given to Pueblo accounts of creation, in which linear movement from one cosmological world into the next necessitates climbing up through a hole in the ground — often aided by Spider — to the next world above. This contrasts with the beliefs of the more northerly peoples, who are lowered from the Sky World down to the Earth World on the Spider's line. For the Pueblo peoples, the reiteration of the earlier Teotihuacano belief that Spider Woman created the Earth from the net she spun over the sea is a recurrent motif throughout the Southwest. In some versions, the Earth is placed on the web, while in others, the Earth is created from slender sticks radiating from the center, with webbing woven in between, as in a spiderweb.

Also revealed in this Pueblo mythology, Grandmother Spider commonly bestows upon humans the gifts of clairvoyance and spiritual power. She plays a prominent role as a figure of the Earth World and the Underworld or Underwater World and is often considered to be responsible for bringing people out of these lower worlds. In other myths, she assists individuals to ascend and descend precipices or to move to and from the Sky World. To

FACING PAGE: An Ojibwa cradle board, or *tikanagan*, collected by Frances Densmore in Minnesota in 1917. The mannequin "baby" is focused on two spiderweb charms that have been suspended from the hoop as a means of catching all that is evil, just as a spiderweb catches and holds everything that comes into contact with it.

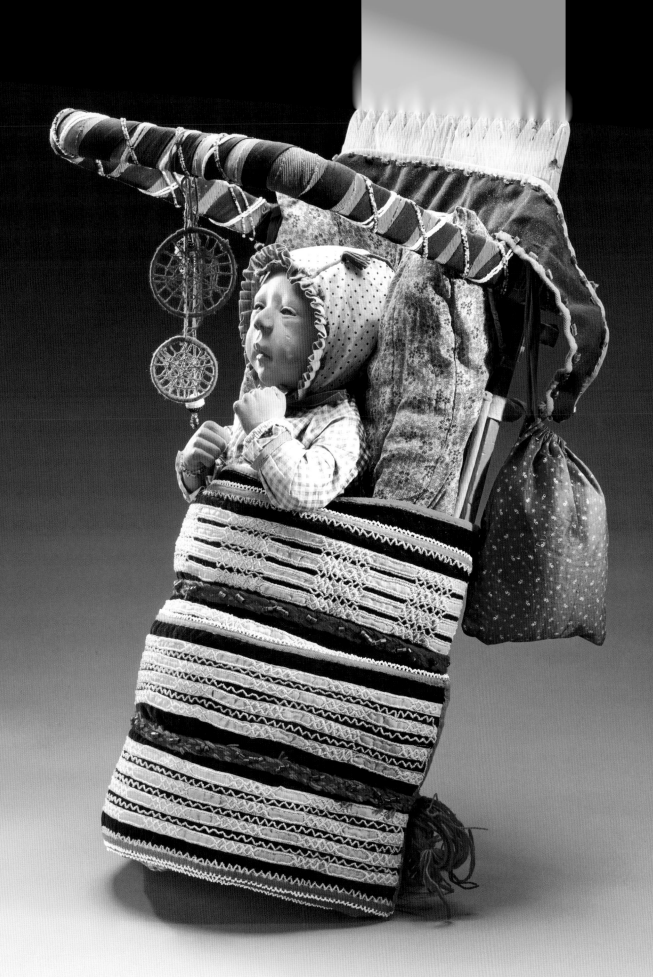

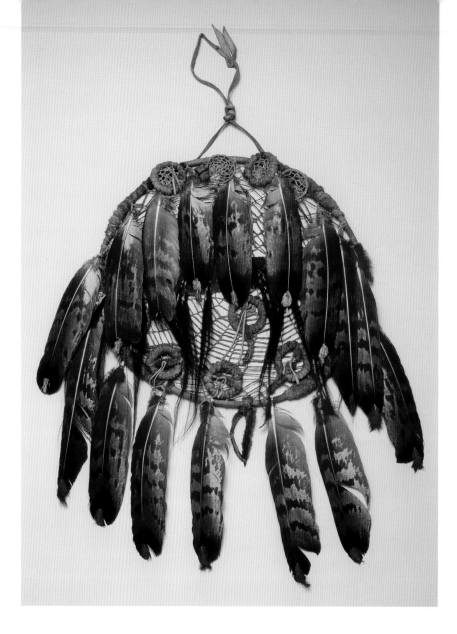

The Lakota Sioux spiderweb shield is based on earlier protective amulets that were often fastened in men's hair or tied on to medicine bundles or personal objects. These small amulets with webbed interiors contained Spider's protective power. The innovative size of the shield itself and the materials it incorporates, however, clearly indicate that it was made for sale rather than ceremonial use.

balance this benevolence, she is found to be related to warfare in Pueblo myth and ritual. While the description provided here merely glosses over the complex and integrated motifs in the mythology, it is apparent that both the Spider Woman deity and the miniature netted shields used by the Pueblo peoples of the American Southwest are visually and functionally similar to those found in Mesoamerica. In all likelihood, they are related historically.

Circular shields in the American Southwest and on the Plains were long

Circular shields in the American Southwest and on the Plains were long considered protective devices, both physically and spiritually. A warrior went into combat fully armed with his shield; without the shield, he lacked the protection of the supernatural to succeed and survive.

considered protective devices, both physically and spiritually. A warrior went into combat fully armed with his shield; without the shield, he lacked the protection of the supernatural to succeed and survive. Shields were decorated with painted images, derived from dreams and visions, amulets, feathers and hide from animals that held specific spiritual qualities. Eventually, these large shields proved to be an ineffective defense against European weaponry and were abandoned. But the protective powers were retained in the form of miniature netted shields tied onto a warrior's scalp lock or around his neck or attached to his clothing. In this way, the shield's power to call upon supernatural aid endured.

Examples of these small netted hoops are found in museums as single objects, as items attached to other objects and in archival photographs. Two such netted hoops, along with two beaded lizard charms and other medicines, are fastened to a brass bead necklace that originally belonged to Lame Bull (circa 1841-1901), a Cheyenne medicine man, and is now part of a private collection. The webbing of one of these hoops has been coated with a red pigment, as has the Crow miniature medicine hoop. The first two hoops measure two inches (5 cm) in diameter; the Crow hoop is four inches (10 cm). The mystical and protective powers of both shields and spiderwebs in these small netted hoops worn by Sioux, Crow and Cheyenne warriors and medicine men symbolized a spiderweb, the protective mantle created by Spider Woman.

Another item with similar features is the circular netted object incised below the throat of a Thunderbird in human guise depicted on a sacred birchbark scroll recovered archaeologically at York Factory, on Hudson Bay. Crosshatching is commonly used to emphasize outlines and fill in areas on figures scratched onto birchbark scrolls. Another piece, recovered from a mound at Hopewell, Ohio, and approximately 2,000 years old, demonstrates the antiquity of the use of two-dimensional net imagery in North America. In what appears to be a parallel usage, an artist has engraved images of faces

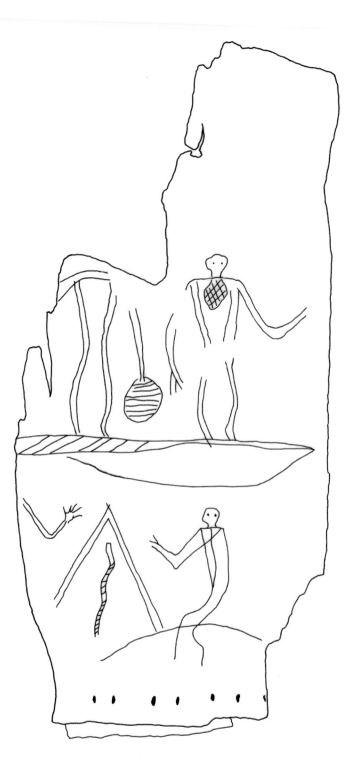

ABOVE: A Thunderbird in his human guise is depicted on a portion of a sacred birchbark scroll recovered archaeologically at York Factory, on Hudson Bay. To ensure the figure's protection, a netted circular object has been incised below his throat. As powerful mythological mediators between the Sky World and the Earth World, Thunderbirds played significant roles in some Native religious ceremonies.

This game, like most Native games of male dexterity
and strength, in which opposing individuals or teams compete,
possesses a strong spiritual component that is
directed toward pleasing the supernatural.

depicted with antler headdresses on a portion of a human femur. The figures are outlined and filled in with similar incised netlike crosshatching.

Visually and symbolically linked to these miniature nets, the netted hoops of the hoop-and-arrow game occur throughout the American Southwest, the Plains and beyond. Such games adhere to group-specific rules that govern the challenge of shooting an arrow through a rolling hoop. Although the origins of this game are obscured by time, it is believed to have symbolic connections with the Twin War Gods of the Southwest and, ultimately, with Spider Woman.

In a lengthy discussion of the hoop-and-pole game in North America, American ethnographer Stewart Culin describes the meaning and function of several miniature netted hoops and their place in relation to the game. This game, like most Native games of male dexterity and strength, in which opposing individuals or teams compete, possesses a strong spiritual component that is directed toward pleasing the supernatural. The netted hoop becomes the feminine aspect, while the dart, arrow or pole (depending on the game) represents the masculine, with all the attendant generative potential.

Very quietly tucked into Culin's description is a line drawing of a Hupa (Hoopa; Athapaskan-speakers in California) cradle charm, which he likens to the Chippewa example described by German ethnologist Johann Georg Kohl. Normally attached to a wicker baby cradle, this three-inch (7.5 cm) Hupa charm is a small hexagonal object made by twisting white and black straw around three sticks placed crosswise, ends equidistant. There is no doubt that conceptually, netted hoops — large or small — serve to protect the wearer or the infant by capturing malevolent forces.

The seemingly contradictory roles of spiders, spiderwebs and protective devices are best explained by the Sioux's (Lakota, Nakoda and Dakota peoples) evaluation of Iktomi, the spider. Particularly in Lakota lore, the spider plays a key role as a provider of beneficial attributes. A young woman is encouraged to exhibit the industriousness of the spider, which builds a home

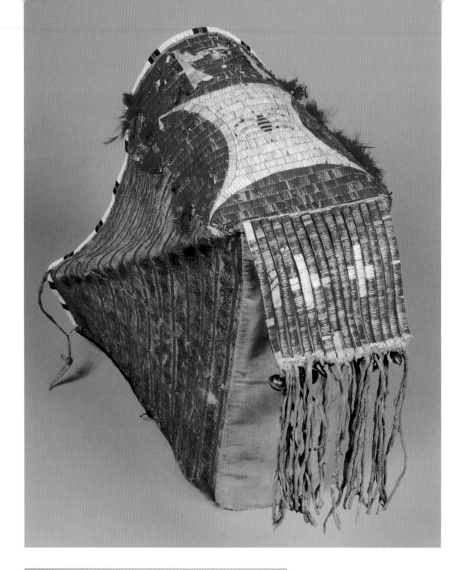

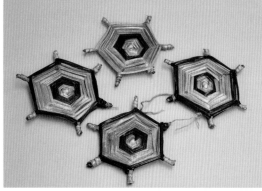

TOP: A spiderweb that has been drawn out at the four corners, with a spider in the center, is prominently featured in this Sioux porcupine quillwork cradle cover (placed over a cradle and shown from the back). The positioning of this protective motif over the baby's fontanel, or "soft spot," is significant, as this tender area on the head is considered to be a point of entry and exit for spirits. ABOVE: These four cradle charms were made by the Hupa (Hoopa), the largest group of Athapaskan-speakers in California. The classic spiderweb form of the charms calls to mind the *neali'ka* of the Huichol of Mexico as a metaphorical protective device.

Depictions of spiderwebs on Sioux items reinforce Iktomi's dual roles. The spiderweb engraved on the blade of an 1860 Hunkpapa Teton Dakota pipe tomahawk manifests the spider's associations with thunder and lightning.

for her children and snares plenty of food for them. A young man would paint images of elks, spiders and whirlwinds on a hide blanket expressly to court and catch the young woman of his choice.

However, as Iktomi, the Great Trickster — comparable to Nana'b'oozoo of the Ojibwa and Tcikapis of the Crees — the spider can also display anti-social behaviors. For hunting groups, the Trickster is complex, easily deceived or tricked in one situation, yet able to command real power in another. Iktomi characterizes this well, for according to historian Ron McCoy, he is seen as dancing across a continuum of behaviors and actions that link extremes. At one end of the continuum, he is sacred; at the other, profane.

Depictions of spiderwebs on Sioux items reinforce Iktomi's dual roles. The spiderweb engraved on the blade of an 1860 Hunkpapa Teton Dakota pipe tomahawk manifests the spider's associations with thunder and lightning. In two-dimensional art, warriors are illustrated wearing buckskin war capes with the typical Sioux-style webs, in which the points of attachment are drawn out into a rectangular form and the sides deeply indented, and their horses are depicted with painted web designs. These webs protect both rider and horse, for the spiderweb is believed to have the power to stop arrows and bullets. For this very reason, Ghost Dance shirts and dresses of the 1890s bore similar designs.

Although the Sioux also express the web as a netted hoop, it is the rectangular, indented cobweb image that is worked in porcupine quills on a child's robe. This design is quilled by a medicine woman, and the web becomes a symbol of power invoked for the future good of the wearer.

Identical webs of porcupine quillwork are placed on the hood of the Sioux cradle cover, which rests over the fontanel (soft spot) of the baby's head. This tender spot is thought to be the place where spirits can pass into the infant's being, so the cobweb entraps bad spirits before they can enter. According to American anthropologist Clark Wissler, the Oglala Sioux carried out a secret ceremony in which a child was taken to an isolated place. There, a swing or hammocklike structure was built in the form of the spi-

derweb design, supported at four corners. The child was then placed on the structure, an act intended to bring good fortune and to ensure the child's development and well-being.

For other nations, such as the Cherokee, the spider was associated with the creation of the world as we know it. The Cherokee praise Grandmother Spider for her vital role in obtaining light from the other side of the world. In this myth, the Fox attempts unsuccessfully to bring back a piece of the sun; then the Possum and the Buzzard each make the same effort. In the end, only Grandmother Spider is able to capture a piece of the sun in a clay pot and drag it home at the end of her silken line. The emphasis here, of course, is on the spider's intelligence and the innate strength of her thread. The myth does not suggest any association with net charms or dream catchers.

The power of lines, particularly for the purpose of protection, is familiar to other Native peoples. As an example, let's turn to the Inland Tlingit, Tagish and Tutchone groups of the southern Yukon Territory. Among these peoples, the sewing of garments served as a metaphor. By taking a line and passing it in and out of the hide or cloth, a woman was able to connect disparate parts into a protective whole. She was expected to do everything she could to protect her husband's life. For that, she relied primarily on a special belt of blackened twisted sinew and swan's down with four knots in it. The day before her husband was to leave on a potentially dangerous hunting expedition, she would put on the belt and wear it throughout his absence. In her blessing of the belt, she would say, "This string is the life of my husband. I'm putting it on so that he will come back safe again from his trip."

Clearly, lines and nets, particularly as replicas of spiderwebs, have provided and continue to provide protection for individuals within a group and, ultimately, to ensure the well-being of the group as a whole. This symbolism resonates throughout North America and down into at least Mesoamerica. Although the Ojibwa have been credited with the inspiration for the dream catcher, it is perhaps because the northern Algonquians — the Ojibwa, Cree and Naskapi peoples — have continued to use net charms almost to the present day. The past usage of these charms in other areas has simply faded from memory.

FACING PAGE: Zuni (upper) and Hopi (lower) examples of the hoop-and-dart game played throughout the American Southwest. The game involves two opposing teams of men, and the count is kept according to which hole in the net the dart penetrates.

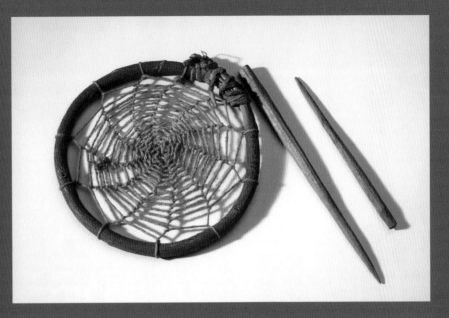

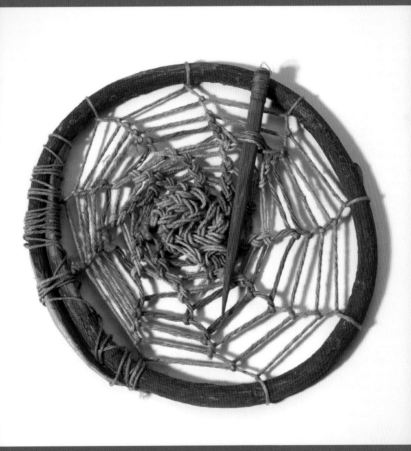

ABOVE: A Crow warrior's hair ornament features a chert (a flintlike rock) projectile point and a long down feather attached to the netting. The application of red ocher, which is rubbed on the netting, reveals its spirituality.

DREAM CATCHERS TODAY

The miniature netted shields, net baby charms, beaver nets, lacrosse sticks and net maple syrup skimmers stand firmly entrenched in Native culture. All share a similar form and a dual, albeit at times contradictory, function, in which beaver, fish, lacrosse balls or illnesses are entrapped or unwanted or malevolent elements, such as insects, debris or bad dreams, are removed. These dual functions found expression as dream catchers, with the first appearing on the powwow trail as early as the 1960s. As powwow participants, organizers and vendors tend to follow a circuit, moving from one tribal venue to another, it is easy to understand how the dream catcher became adopted by a range of other Native peoples, eventually becoming a symbol of Native unity and identity. At the same time, it came to represent a profound and recognized spirituality.

Now that the mass production of these items has flooded the market, some Natives have expressed dissatisfaction and are losing interest in the dream catcher as a symbol of solidarity. This feeling is far from being universal, however, as many individuals and groups still adhere to the beliefs inherent in the dream catcher.

Indeed, a number of tribal legends have been proffered in recent years to explain the dream catcher's origin. Among the Lakota Sioux, several versions tell essentially the same story. When the world was young, a spiritual

While spinning the web, the spider spoke of the cycle of life from infancy to old age. It described both good and bad forces in the cosmos. The bad forces can be harmful, but the good forces can lead a person in a positive direction in harmony with nature.

elder went to a mountain with an offering of a willow hoop decorated with beads and feathers. While on the mountain, he had a vision in which Iktomi (Inktomi; Unktomi), the Great Trickster, appeared to him in his guise as a spider. As the old man and the spider talked, the spider took the willow hoop and began to spin a web inside it.

While spinning the web, the spider spoke of the cycle of life from infancy to old age. It described both good and bad forces in the cosmos. The bad forces can be harmful, but the good forces can lead a person in a positive direction in harmony with nature. Once the intricate web was finished, the spider presented it to the old man and told him to use it to help himself and his people. If you believe in the Great Spirit, the web will catch the good ideas and allow the bad ones to flow through the hole.

The seemingly paradoxical nature of Iktomi is revealed through his multiple characteristics and personalities. The spider is regarded by the Lakota Sioux as a cosmological traveler, capable of traveling everywhere — through the sky, to the place between the sky and the clouds, to the Earth and beneath the Earth. It is, therefore, the wisest of creatures and is particularly knowledgeable about sacred things. The different types of personalities exhibited by the spider echo the numerous forms assumed by Iktomi. Thus the spider, its web and its many characteristics play a prime role in Lakota Sioux culture and mythology.

The function of the Lakota Sioux netting to catch good ideas (dreams) contrasts with its function in the Ojibwa legend, which contends that the bad dreams are caught and the good dreams slip through the hole. The Ojibwa story tells of a kindly grandmother, Nokomis, who stops her grandson from killing a spider spinning a web. The spider, grateful to Nokomis for saving her life, rewards the old woman by spinning a magic web. The spider tells her that the web is to be hung above her bed, where it will catch bad dreams in the silky threads, while good dreams will find their way through the hole in the center of the web. After being caught in the web,

The spider, grateful to Nokomis for saving her life,
rewards the old woman by spinning a magic web.
The spider tells her that the web is to be hung above her bed,
where it will catch bad dreams in the silky threads, while good dreams
will find their way through the hole in the center of the web.

the bad dreams will disappear with dawn's first light. In the Ojibwa language, the dream catcher is called *asabikeshiinh*, the inanimate form for "spider," or by the more modern phrase *bawaajige nagwaagan*, meaning "dream snare."

Today, individuals from a variety of Iroquoian groups make dream catchers for personal use as well as for the marketplace. Without claiming to be the originators, they have incorporated the dream catcher into their art and culture, complete with their versions of the dream catcher legend. One Haudenosaunee (Iroquois) variation, which is ambiguous about the legend's attribution, begins when the child of a Woodland chief (who could be either Ojibwa or Iroquois) falls ill and is unable to sleep due to bad dreams and fever. As we've learned from the Ojibwa version of this story, the tribe's medicine woman forms a circle from a willow branch and weaves a web in the center with sinew, borrowing the pattern from the spider. The dream catcher is hung over the bed of the sick child, and soon the fever breaks and the child sleeps peacefully. The Iroquois at the Pine Tree Native Centre of Brant County, in Ontario, Canada, are now making dream catchers: "With our warm hearts...especially for you. May your dream catcher bring everything it is supposed to."

The Iroquois are distributed from eastern Canada and the United States into the Midwest, and the sharing of art forms and ideas with neighboring groups has become an accepted practice. An exchange of goods and ideas regularly takes place at celebratory intertribal gatherings such as powwows. Native identity, cohesiveness and spirituality are reinforced on these occa-

FACING PAGE: *Long Wolf* by Nick Huard. Photograph by Jan Thijs. Materials: Wolf skull, caribou antlers, obsidian arrowhead, red-tailed hawk feathers, goose feathers, caribou fur, caribou babiche.

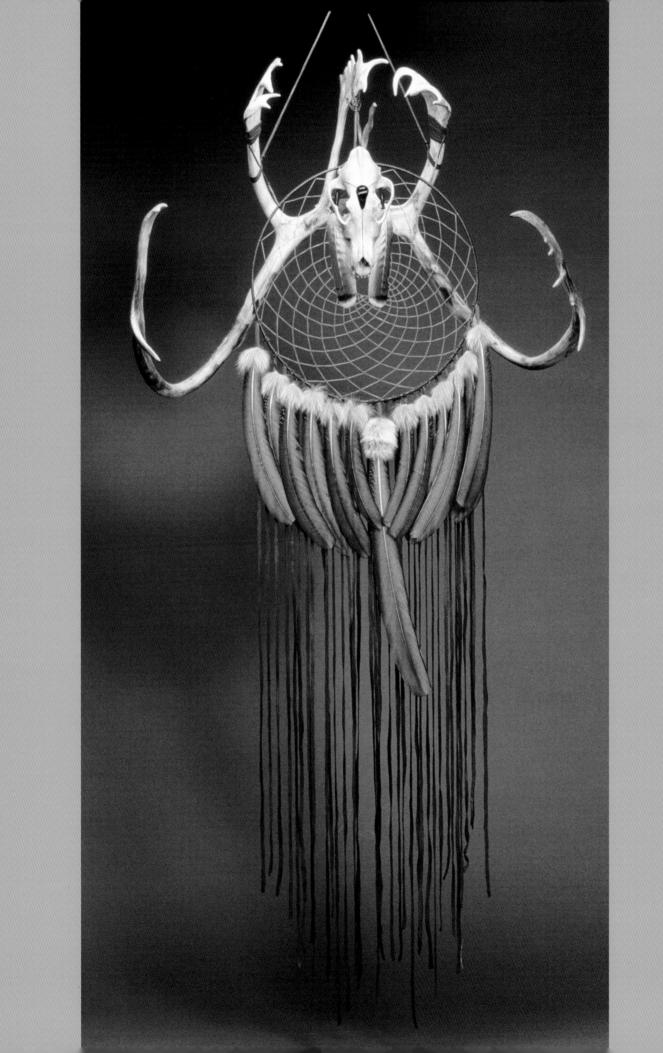

The Walking-Out Ceremony marks the occasion when a toddler,
who has spent the first year or so laced into a *tikanagan* whenever he or she is outside
the *michuap*, or tent, walks from the sanctity of the home, across the threshold and into
the community area. Feasting and gift giving mark this auspicious event.

sions. As Huron artist Anne Marin reveals, she focuses on the spirituality of her dream catchers during the making and marketing of them to other Natives at powwows. In a leap that transformed the dream catcher from the celebration of an individual's art to the expression of a larger group, the Seneca Nation opened the Dream Catcher Art Center in Irving, New York, in 1995 to showcase Iroquoian art.

In the American Southwest, the Navajo have a legend explaining how they, too, received this gift from the spider. Dream catchers offered for sale by the Navajo are guaranteed to have been handcrafted by the Navajo Nation.

Similar stories can be documented from one Native group to another across North America. For example, in Mission, British Columbia, a Canadian business that began selling dream catchers out of a van at powwows nearly 25 years ago is now a large, successful wholesale company with more than 80 subcontractors handcrafting dream catchers from family designs. While the material of the hoops is not identified, all the other components are: Hides are produced from cows, goats, sheep and pigs; feathers are from domestic turkeys, ducks and chickens. In addition, there is an assurance that no eagle feathers have been used. In response to market demand and to pique the interest of buyers, the company has developed new merchandise, such as polished stone pendants with silver dream catchers and pottery with dream catcher inserts; has introduced new materials, such as Swarovski crystals and semiprecious stones; and has updated its descriptions to note that crystals assist in removing negative thoughts and that semiprecious stones enhance spiritual communication. Despite all these developments, the company continues to acknowledge that the dream catcher originated with the Ojibwa.

Just as the spider gave the Natives the skills to create their own netted hoops, the gifting of dream catchers has carried over into special ceremonies and tribal exchanges, reflecting a strong belief in the power of the dream catcher and conveying all the cultural values that have been instilled in the

This modern Ojibwa dream catcher is handcrafted and distributed by a company in Mission, British Columbia. On an attached card, the dream catcher legend is offered in both English and French, indicative of the dream catcher's role in the commercial Canadian market.

presenter. The acceptance of such gifts reinforces and legitimizes these beliefs. Among the Crees of the James Bay area, for example, the Walking-Out Ceremony marks the occasion when a toddler, who has spent the first year or so laced into a *tikanagan* whenever he or she is outside the *michuap*, or tent, walks from the sanctity of the home, across the threshold and into the community area. Feasting and gift giving mark this auspicious event. In the case of a young Cree girl, the presentation of an eagle feather and a dream catcher by her maternal grandparents resonates with cultural values.

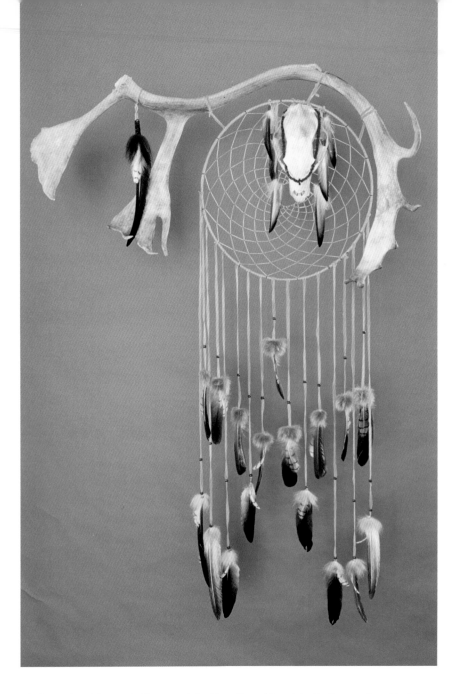

Black Bear by Nick Huard. Photograph by Pierre Dury. Materials: Caribou antlers, black bear skull, wolf fur, goose feathers, glass beads, caribou babiche.

The gift of a dream catcher from a Native group to a Native-owned museum in the eastern United States in 1999 not only denotes a mutual appreciation of the meaning of the dream catcher but also connotes the blending of Native spiritual beliefs with the Christian religion introduced by missionaries. The gift was intended as an ornament for one of the symbols of Christianity: the Christmas tree. The Nanticoke Indian Association of Delaware presented a dream catcher as a decoration for the museum's hol-

The adoption of the dream catcher from the Ojibwa is now considered to be traditional among several maritime groups. Its association with spiders and spiderwebs coincides with the reverence accorded the spider in these groups.

iday "Tree of Nations." Eight inches (20.3 cm) in diameter, the dream catcher was created using modern materials, including bone beads and rooster-hackle drops. Worked into the webbing are small letter beads that spell "Nanticoke" and "Delaware." A little sterling silver turtle provides the finishing touch. This presentation from one tribe to another and its acceptance endorses the value of the gift on many levels.

Farther north, the presence of dream catchers on the Atlantic coast is a fairly recent cultural addition. Here, the web is thought to catch good dreams and to transform bad dreams into good ones. Spiritual leaders in Newfoundland and Nova Scotia readily admit that historically, they have not used webbed charms like these. Only within the past two to three decades have they begun to make them for their own purposes and to sell to outsiders.

But the maritime peoples have long-held beliefs about strings and lines, which have special import when a birth is imminent. Activities such as walking under a clothesline or knitting are to be avoided by the mother-to-be, as are wearing rings or necklaces or tying anything around the waist. However, the dream catcher's inherent spiritual ideology, symbolism and physical presence in the Mi'kmaq communities have been easily incorporated into Mi'kmaq Roman Catholicism.

The decoration of the church at Whycocomagh in Cape Breton, Nova Scotia, at Christmas in recent years illustrates this combining of native spirituality and Christianity. Dream catchers are hung in every window, and the crèche scene and the Christmas tree are positioned under the watchful eye of Christ's image mounted on a dream catcher.

The adoption of the dream catcher from the Ojibwa is now considered to be traditional among other maritime groups. Its association with spiders and spiderwebs coincides with the reverence accorded the spider in these groups. Historically, Malecite shamans utilized spiders to provide medicine for healing and to assist in removing disease from ailing persons, and cobwebs were used to staunch bleeding. People are admonished not to kill a spider as it could be someone's animal spirit helper. The Penobscot and Pas-

samaquoddy promote dream catchers as having the ability to capture good dreams, a property that is manifested in the local bingo hall, which is hung with nearly one hundred dream catchers intended to catch the good (winning) numbers for the players' bingo cards.

In the Canadian West, a dream catcher collected in 1999 from Clifford Crane Bear, a Siksika of the Blackfoot Confederacy near Calgary, Alberta, is currently housed in the Museum of Archaeology and Anthropology at the University of Cambridge in England. The catalog description notes the use of willow for the frame, with sinew webbing decorated with six beads and one shell. Four tassels of soft suede, two on each side, are attached to the sides of the frame. These, in turn, are decorated with yellow feathers, gold and yellow beads and silver tubes. At the top of the frame is a hanging loop. Here, the artist explains his choice of materials and their meanings:

> **willow**: wood gives life and comes from the trees,
> which are trees of life; branches extend, which leads
> to many children
> **mother-of-pearl shell**: good luck and longevity;
> like the ancestors
> **circular shape**: circle of life
> **four strings**: four directions
> **seven objects**: Big Dipper (Ursa Major)
> **four colors**: four races
> **silver and gold**: bright colors attract bad dreams
> and take them away
> **yellow**: sun
> **blue**: river
> **green**: grass
> **red**: earth

At Oujé-Bougoumou, Quebec, a new cultural center for the Crees has been built as a permanent form of a *shaptuwan*, or traditional Cree gathering place for feasts. The design serves as a multifunctional space, with room for displays, exhibitions and a museum collection. In addition to heritage pieces, the directors are acquiring dream catchers to display in the museum; others will be sold in the museum shop. As has been noted, the Crees made and used net charms and miniature fishnets to protect infants from harm, and now they accept dream catchers as both an updated version of this traditional item and a material manifestation of the more recent pan-Indian movement. Today, dream catchers are meaningful objects for the Crees.

For many of the craftspeople in North America, the knowledge
and skills needed to create netted hoops, either as cradle charms
or as miniature protective shields for warriors, have been lost or forgotten.

One area not usually explored in regard to dream catchers is their
importance in the transmission and acquisition of cultural knowledge. For
many of the craftspeople in North America, the knowledge and skills needed
to create netted hoops, either as cradle charms or as miniature protective
shields for warriors, have been lost or forgotten. Certainly, none of the craft
books available prior to the proliferation of dream catchers make reference
to net cradle charms or netted hoops. Granted, most of these publications
were — and continue to be — designed for non-Native crafters and were
often prepared by non-Natives.

This vacuum reveals the extent to which cultural knowledge has been
lost over the years. An eagerness to learn these skills has been met in a num-
ber of ways, including individual instruction from another maker, workshops
by both Natives and non-Natives and the purchase of kits. Today, many
Native artisans who create dream catchers inform purchasers that they have
been taught by a mother or grandmother. It appears that the cultural knowl-
edge is now being handed down through the generations by the Natives
themselves.

Further afield, the webbing of the dream catcher has been incorporated
into the "hoops" of the staffs of contemporary Plains warrior societies. An
eagle staff, complete with webbing, was prominently displayed beside then
Canadian Prime Minister Jean Chrétien when he addressed an audience gath-
ered to celebrate the launch of the First Nations Bank of Canada in Toronto,
Ontario, in December 1996. In this modern rendition, the webbed area of
the staff harks back to the miniature shields worn for protection by warriors
and the protective mantles provided by Grandmother Spider. Even further
afield is the dream catcher that was seen hanging in the window of an Inuit
home on the east coast of Labrador.

Dream catchers have become an icon of Native identity throughout
North America and beyond. The icon's power has also caught the attention
of individuals who have learned that part of their heritage is, in fact, Native.
In their explorations of Native culture and imagery, they have developed a

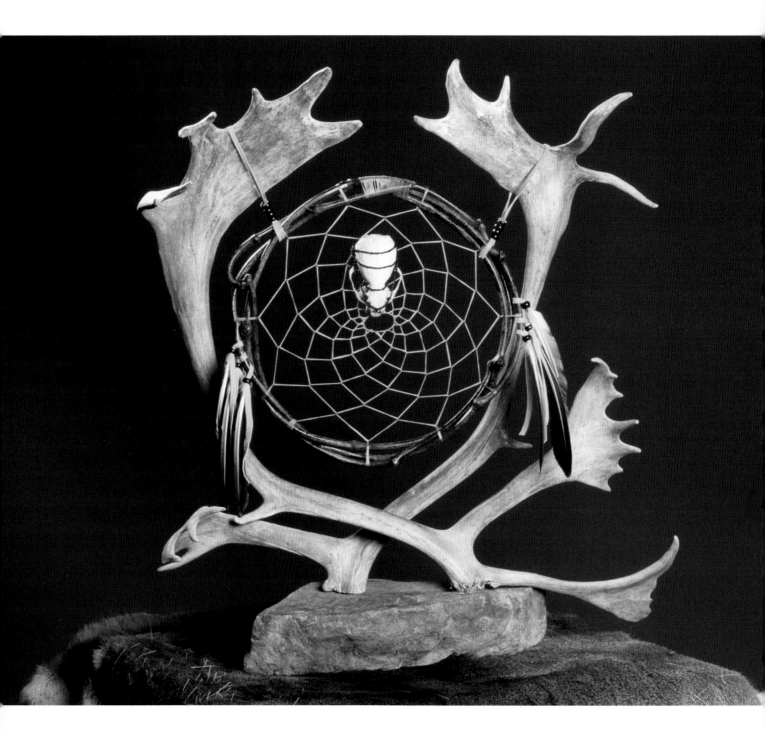

Otter by Nick Huard. Photograph by Jan Thijs. Materials: Caribou antlers, otter skull, wild vines, goose feathers, glass beads, caribou babiche, rock with veins of copper.

Many Native artists have expressed this new confidence by incorporating dream catchers and other Native icons into their two-dimensional paintings and prints. Artisans working in three-dimensional forms have drawn upon their artistic sensibilities by transforming the classic dream catcher into an art piece.

visual language — one that includes the images of dream catchers, feathers, beads and other items with Native associations — to bridge their newly discovered relationship with two (or more) cultures. Those who may, in the past, have been ashamed of their Native blood have embraced the changed attitudes toward Native identity, due, at least in part, to the strong awareness and acceptance of Native strengths through the widespread presence of the dream catcher.

Many Native artists have expressed this new confidence by incorporating dream catchers and other Native icons into their two-dimensional paintings and prints. Artisans working in three-dimensional forms have drawn upon their artistic sensibilities by transforming the classic dream catcher into an art piece. One, two and sometimes even three dream catchers may include spiral attachments or are bound together to create interesting shapes, some overlapping, others at perpendicular angles. One western artist's addition of candle holders and votive lights has turned these multicomponent examples into pieces of art worthy of display.

Some other artists have enhanced the traditional webbed circular form by attaching items that are particularly meaningful to their cultural upbringing. Mi'kmaq artist Nick Huard, whose work appears throughout this book, promotes his installation-sized dream catchers as an art form inspired by his own dreams. The decorative elements incorporated into his pieces are found objects collected from nature and during his travels and are of special significance to Huard. For other Native artists, the dream catcher has been an inspiration to create and enhance their work with intricate patterns of webbing and complex designs fashioned with glass beads and beaded fringes.

Several dream catchers crafted by Natives to demonstrate their aboriginal identity appear, instead, to stretch the identity of the dream catcher itself. These derivative forms differ from those incorporated as the background or as an integrated element in paintings and prints. Nor do they replicate the basic recognizable form that has been elaborated on or trans-

Just as pan-Indianism evolved from a resistance movement into a more tempered expression of solidarity in the marketing of Native spirituality, the dream catcher has become a public icon that acknowledges and demonstrates that Indianness.

formed by the artists noted above. While these dream catchers have hoops, usually wrapped with strips of soft tanned hide, the center is not webbed. Instead, a piece of hide is laced onto the hoop and is usually decorated in some fashion. The finished appearance is reminiscent of a beaver pelt laced onto a stretcher, or frame.

A large dream catcher in this new form was one of many Native items on display at the opening of a First Nations restaurant in Ottawa. The central area of this Cree dream catcher has a beaded floral design. Another example is a graphic image with four pendant feathers and a map of Newfoundland in the center, which has been adopted as the logo of the Federation of Newfoundland Indians. A 2003 news release involving the Passamaquoddy tribe in Maine includes a photograph of an elder standing in front of a dream catcher that has a large spear point cut out of hide with an eagle staff and a feather staff. Similar in composition are paintings on hide by Cree artist Ernie Scoles, marketed in 1994 not as dream catchers per se but as art "mounted in the traditional way." A variation on this genre incorporates a piece of dyed hide or cloth within the circle, while the remainder of the circle is netted. This version serves to link the classic dream catcher form with the derivative form.

Just as pan-Indianism evolved from a resistance movement into a more tempered expression of solidarity in the marketing of Native spirituality, the dream catcher has become a public icon that acknowledges and demonstrates that Indianness. Together, these objects and their various legends conjure up romanticized images of cultural ideals and traditions; of a people intimately in tune with nature; of communication between the spirit world and the human world; of a simpler past, when the world was suffused with universal love and a shared concern for one another; and the implied promise that this will again become a reality.

For the Native makers, dream catchers exemplify and tangibly acknowledge their cultural values, their beliefs in the revelations and efficacious nature of dreams and, ultimately, their personal identity.

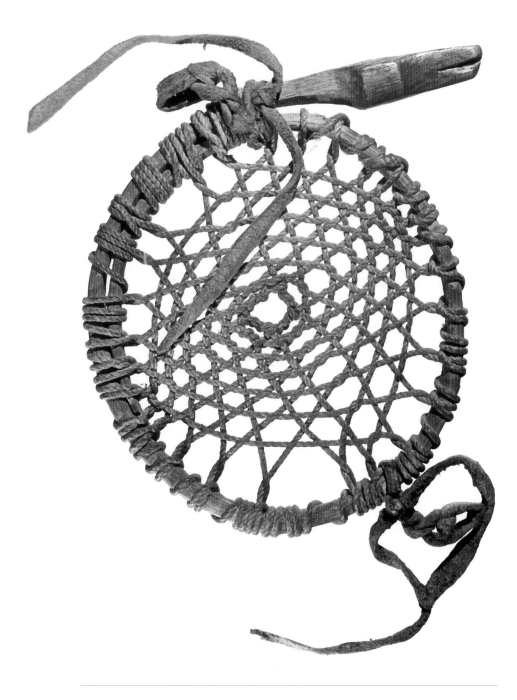

The wooden hoop of a Cheyenne hair ornament is finished with the carved head of a snake. To the warrior who tied this protective netted object to his scalp lock, the snake held a specific personal meaning.

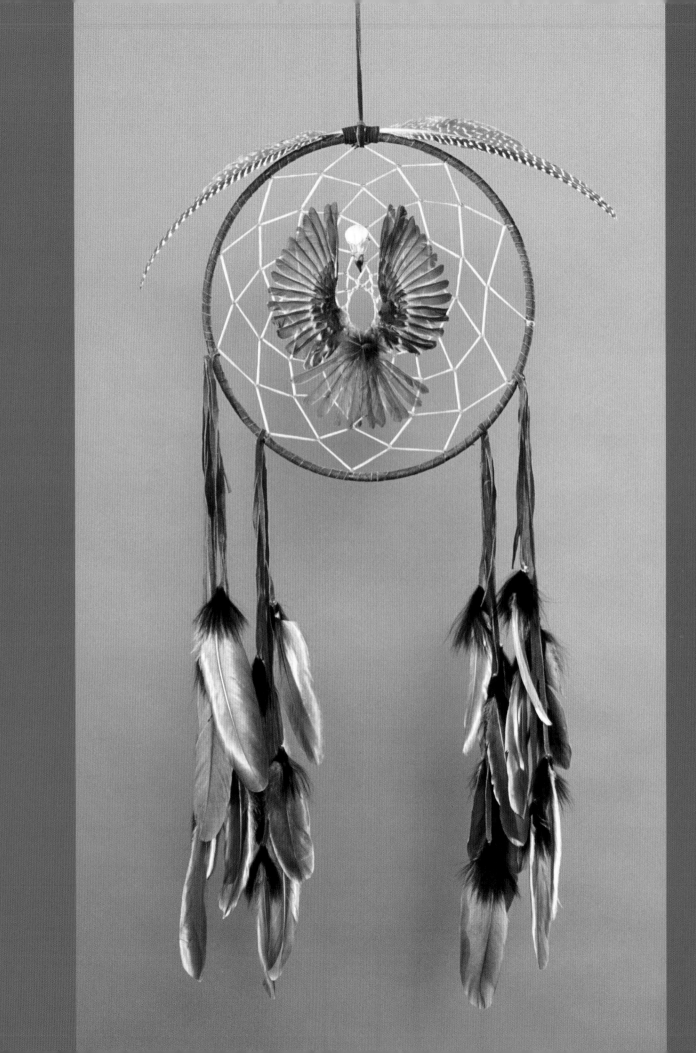

Scale

The dream catcher seems to inspire a certain competitive spirit. While the controversy about its original creator has been resolved, a number of communities now claim to be home to the world's largest dream catcher, only one of which is Ojibwa. The first of these may well be the one displayed on Route 66 at Meteor City, Arizona. To the west, a small town in northern California called Happy Camp hosts a 33-foot-diameter (10 m) dream catcher, complete with spider and Christmas lights. The Zhiibaahaasing First Nation (Ojibwa) at the western tip of Manitoulin Island, in Lake Huron, makes the same boast, with a dream catcher that measures roughly 20 feet (6 m) in diameter. Suspended in the center is a piece of Manitoulin's white dolostone, riddled with circular holes that were formed by water and pebble erosion. Associated with this world-class dream catcher are the world's largest drum and the world's largest peace pipe, all designed to attract visitors. In the James Bay community of Fort Albany, a large dream catcher has been erected over the front circle area of the new school, the site of drum circles and sacred fires.

In his play *The Berlin Blues*, Ojibwa playwright and author Drew Hayden Taylor continues his efforts to bridge the gap between Native culture and dominant society through humor. The story revolves around a pair of wannabe Natives inspired by Karl May, a late-19th-century German writer who specialized in adventure novels set in the Old West. The pair arrive at a small Ojibwa reservation with a well-financed offer to build and market a theme park to attract tourists. One of the main attractions is a dream catcher that measures 44.44 meters in diameter — to symbolize the number four, "which Native Americans considered sacred" — whose webbing is created by crosshatched laser beams. It's an eye-catching, can't-miss feature that dominates the landscape.

This is Taylor's humorous poke at the iconic stature that dream catchers

FACING PAGE: *Sparrow* by Nick Huard. Photograph by Pierre Dury. Materials: Guinea hen feathers, sparrow feathers, goose feathers, sparrow skull, caribou babiche.

have attained, particularly with non-Natives. The entire venture ultimately fails when the Ojibwa come to their senses, realizing that they are selling their souls, and withdraw from the deal.

FASCINATION WITH 'INDIANS'

Why have dream catchers become so popular in our modern global culture? A partial answer rests with the passionate and enduring fascination with Native Americans exhibited by Europeans, Euro-Americans and other nationalities since their earliest introduction to the indigenous peoples of the New World. A brief historical overview offers one interpretation of the way this fascination with "Indians" has developed and been expressed through the years.

As long as people have been arriving in North America from other countries and continents, they've been sending Native artifacts back to the people and communities they left behind. Intended to illuminate the culture, conditions and circumstances of this new landscape, that eclectic archive of souvenir items crossed the ocean on ships and arrived in home ports, where the artifacts were dispersed to families or sponsors and offered as gifts of tribute to members of the nobility. Depending on the time and place, the recipients of these gifts viewed the items variously as exotic curiosities, proof of savagery, aesthetically pleasing evidence of indigenous skills, romantic and evocative works of the noble savage and marvelous costuming for dress-up and playacting.

Inanimate items were not the only aspect of Native North American culture to make that journey across the Atlantic Ocean. In the 16th century, individual Indians and Eskimos were packed into ships and transported as living exhibits, to be paraded first past members of the European ruling class and, ultimately, before all social classes. In the mid-1500s, Iroquoians were captured and sent across the Atlantic to France, even as Algonquians of the Atlantic seaboard were shipped to Britain. In the late 1620s, three Mi'kmaq found themselves in Britain, while in 1644, a "wild Indian named Jaques" of the Munsee tribe was taken to Amsterdam to be shown off as a curiosity.

FACING PAGE: The entrance sign to the Zhiibaahaasing First Nation's Dreamcatcher Park on Manitoulin Island announces that it is the home of "The World's Largest Dream Catcher." Some 20 feet (6 m) in diameter, the dream catcher is said to have the power to protect every member of the community.

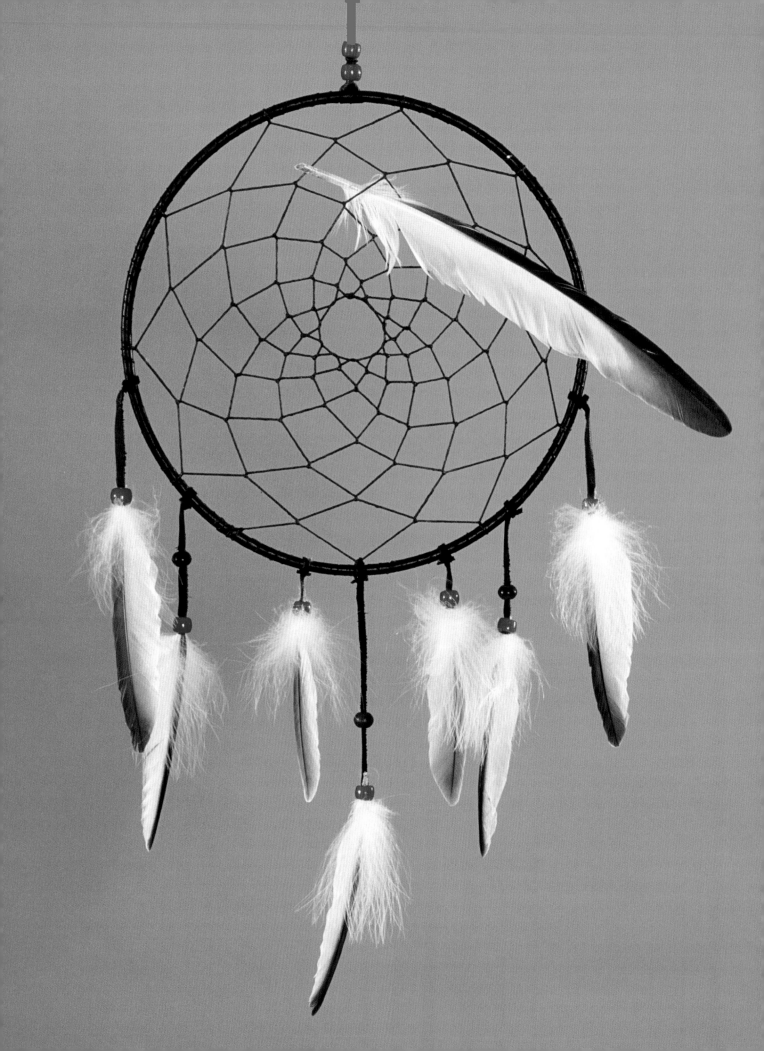

While non-Natives were earning a livelihood and a reputation
on the other side of the Atlantic by exhibiting Natives in their "savage" state
through tableaux and scenes, the Natives in North America were
being encouraged to give up those "savage" ways and become "civilized."

An admission fee was charged for the opportunity to view these "savages" from a strange land.

There is little to suggest that Prince Attash, a Cree who was likely from the Rupert River area of James Bay, was put on public display during his 1675 visit to Britain, nor were the four Mohawk "kings" who went to Britain in 1710. Rather, they came as delegates from the Iroquois Confederacy on a mission to cement an alliance with Britain, as did the famed Joseph Brant in 1775. Even so, they were entertained and feted by the nobility and royalty, perhaps a more civilized and acceptable form of exhibition, all things considered. Certainly, Mohawks from what is now New York State were regularly shown off in Britain and Europe during the 18th century.

American artist and amateur ethnographer George Catlin perhaps takes the lion's share of credit for stoking the flames of Europe's fascination for all things Native American. In 1840, Catlin set up an incredible exhibition in London, England, displaying his collection of 507 paintings of Native Americans from 48 tribes as well as several hundred Indian artifacts, including a Crow lodge large enough to shelter 80 people. He then hired 20 British men and women, dressed them up as Indians and trained them to reenact both war and domestic scenes to enliven his lectures on Indian life.

In 1843, when nine Ojibwa arrived in Britain and asked for his support, Catlin seized the opportunity to take these real Indians on an exhibition tour. The Ojibwa were succeeded by 14 Iowas in 1844, and these, in turn, were replaced with another 11 Ojibwa in 1845. All danced before the royalty of Britain and Europe, an entertainment that was carefully recorded by Catlin and other artists. Catlin also published a number of books, many of them designed to entice children into the lore of Native Americans. These, in addi-

FACING PAGE: *Breeze* by Nick Huard. Photograph by Pierre Dury. Materials: Petrel feathers, glass beads, waxed linen webbing.

William "Buffalo Bill" Cody with a few Native American performers at Sioux Falls, South Dakota. In the last decades of the 1800s, his Wild West shows were incredibly popular.

tion to his popular interpretations, helped to cultivate an intense interest in Britain in anything Native American, and Catlin's work became a standard source of information on Native culture.

While non-Natives were earning a living and a reputation on the other side of the Atlantic by exhibiting Natives in their "savage" state, the Natives in North America were being encouraged, usually violently, to give up those "savage" ways and become "civilized" in the fashion of their colonizers. This push to force indigenous peoples to abandon their traditions included massive relocation programs to reservations, where they were expected to make a living on a radically reduced land base, even as they suffered from the diseases that had arrived with the Europeans. Inevitably, these and a range of other circumstances led to poverty and subsistence living. During the 1800s, strictly

In a visual pun, "Buffalo Bill" Cody is shown riding a buffalo in this 1896 advertising poster for the Buffalo Pitts company, which produced engines and threshers in Buffalo, New York.

as a means of economic survival, some Natives turned to performing for white audiences.

The first two documented performances took place in New York City in 1827, when a troupe of Iroquois performed both a Marriage Dance and a War Dance for the public. Fifteen years later, and predating his touring circus, P.T. Barnum opened the extravagantly advertised American Museum, also in New York City, which featured an enormous compendium of exhibits that included Arapaho, Cheyenne, Comanche and Kiowa Native Americans dressed in full regalia and reenacting traditional ceremonies. Vaudeville and traveling shows presented Native performers in plays, such as the popular *Pocahontas* and the Hiawatha Pageant, along with shorter vignettes depicting warriors, medicine men and Indian princesses.

PART THREE

The diaries of Molly Spotted Elk
provide a revealing glimpse into the challenges
of a Native trying to make a living on the stage.

Then came William "Buffalo Bill" Cody and his Wild West show. Launched in 1883, this unprecedented entertainment featured live performances by cowboys and Indians demonstrating their various skills. Well-known and highly respected performers, such as Sitting Bull, the great Sioux chief, sharpshooter Annie Oakley, Sioux holy man Black Elk and Métis military leader Gabriel Dumont provided the requisite authenticity. When the show visited Canada, 18 train cars were needed to carry the complete entourage of 150 cowboys, Mexicans and Indians, plus animals and sets.

In the spring of 1887, the all-star cast, 97 Indians and 200 animals set sail for Britain, where they performed daily to the delight of large crowds. Even Queen Victoria was entranced by the show and commanded a second performance to be held at Windsor Castle for the enjoyment of the kings and queens of Belgium, Denmark, Greece and Saxony. In her diary, the queen noted that the show satisfied a morbid fascination with Indian exoticism at a range close enough to marvel in, yet not too close to be threatening. Her observations echoed the sentiment of the time. Cody's genius lay in his ability to convince audiences that he was giving them a firsthand look at what a Native American was really like.

Although many Natives left the show after one or two seasons, homesick for their families and their land, Cody and his many emulators entertained Europeans with their productions until the beginning of the First World War. On the other side of the Atlantic, Native Americans, sometimes as individuals and sometimes in small groups, continued to give local performances and participate in vaudeville shows. The diaries of Mary Alice Nelson, a university-educated woman from the Penobscot reservation in Maine, provide a revealing glimpse into the challenges of a Native American trying to make a living on the stage. Nelson chose "Molly Spotted Elk" as her stage name, and she had a number of talents, particularly as a dancer. Nevertheless, with her obvious Native features, Nelson found the living was tough and discrimination rife. Only in Paris did she feel admired as a dancer rather than as the more demeaning "Indian dancer."

Dressed in a Plains dress and a headband with feather in this portrait, Molly Spotted Elk, a Penobscot dancer, is promoted as a "typical Indian maiden." Molly Spotted Elk was both educated and talented and spent many years entertaining American and European audiences as a dancer, troupe performer and movie star.

Prior to Nelson's departure for Europe, her dancing and acting abilities brought her to Canada, where she was the female lead in one of the last silent movies, *The Silent Enemy*, released in 1930. Chief Buffalo Child Long Lance and Chauncey Yellow Robe were the male leads, and the remaining Native parts were played by Ojibwa from the area around Bear Island, in Lake

PART THREE

The popularity of Ernest Thompson Seton's books, including *The Book of Woodcraft and Indian Lore*, led to the formation of a youth movement that was initially called the League of the Woodcraft Indians.

Temagami. Here, Nelson's path crossed that of local girl, movie extra and self-declared guide Madeline Katt Theriault, who taught many of the actors how to snowshoe and survive in the northern climate.

The continuing production of movies, pageants, books for all ages and other forms of entertainment ensured that the Natives, whether they were playing roles or simply being themselves, remained in the forefront as the intriguing "other." Train service spanning the continent from coast to coast allowed great hordes of tourists to encounter the Native peoples of the West and Southwest. Now Canadians and Americans could meet firsthand the Natives in their own communities and on reservations and be alternately amazed and horrified by Snake Dances, Scalp Dances and other ceremonies performed for their benefit. Wonderful souvenirs for family and friends could be purchased to verify and authenticate these exciting new experiences.

In addition to these more spectacular and colorful adventures, interest in Native lore emerged on another level. Born in Britain in 1860, Ernest Thompson Seton moved to Canada with his family when he was six. He became enthralled with Indians after reading James Fenimore Cooper's *The Last of the Mohicans* at the age of 12. He eagerly created a role for himself as an Indian in a play he'd written for his friends and tried to organize his pals into an Indian tribe, thus creating the groundwork for his later writings. In 1903, his first successful boys' novel, *Two Little Savages,* appeared in print. The novel actually serves as a practical handbook of woodlore for children, crammed as it is with diagrams and instructions for erecting tepees, camping, sewing leather moccasins, making a fire by rubbing sticks together, reading smoke signals and many other woodcraft skills.

The popularity of Seton's books, including *The Book of Woodcraft and Indian Lore* (1912), led to the formation of a youth movement initially called the League of the Woodcraft Indians (later changed to the Woodcraft League of America). Seton's views at the time ran counter to the popular stereotype of the "drunken, lazy Indian" by promoting the Indian as an appropriate role

Ernest Thompson Seton's interest in Natives and woodcrafts was inspired by his boyhood experiences camping in homemade tepees with neighborhood friends as they attempted to emulate Native thinking and learn how to survive in the wild. This eventually generated Seton's vision of a youth club based on an American Indian model — a vision that ultimately grew into the Woodcraft League of America.

Chief Buffalo Child Long Lance, journalist, author and movie actor, identified himself first as a Cherokee and then as a full-blooded Blackfoot. During the filming of *The Silent Enemy*, it was revealed that his background was far more complex. He was white, Indian and black.

model. His respected background as an established naturalist, lecturer, artist and author overshadowed the negative attitudes and made the movement a success.

Group activities focused on acquiring outdoor skills, such as canoeing, fire-making, nature studies, archery, stalking, and so forth, all undertaken by young boys in the guise of figurative Natives. Not to be outdone, a girls' group called the Camp Fire Girls formed a parallel movement. While some feel that Seton's woodcraft movement grew into the Boy Scouts in North America, others attribute the formation of scouting to Robert Baden-Powell. One major difference between the two is apparent: Baden-Powell did not formulate the British movement based on Native characteristics but, rather, on a military model, complete with uniforms. In America, the Native component remained a defining aspect.

"Playing Indian" has been a pervasive form of expression since the first

In person, Buffalo Child Long Lance presented a
captivating picture of chiseled manhood, complemented by his academic
and athletic accomplishments at the Carlisle Indian Industrial School.

contact between Natives and non-Natives. On one hand, pressure has been exerted on Native Americans to play Indians in theatrical performances and reenactments, whether as captives exhibited in Britain and Europe, on stage on both sides of the Atlantic or on their tribal lands. On the other hand, non-Natives have appropriated the "Indian" persona as one of their own expressions. From playing cowboys and Indians as young children and following the Scouting and camp programs to the dress-up occasions of costume parties and dramatic enactments, Europeans and Euro-Americans have delighted in becoming tribal braves, warriors, chiefs and Indian maidens, if only for a fleeting moment.

Consequently, anyone or anything connected with Native life was often admired and imitated. Toward the end of the 19th century, when poet E. Pauline Johnson of Mohawk and English heritage was first introduced to non-Native audiences, she became an instant hit. Her lyrical poetry — such classics as "The Song My Paddle Sings" and others with a strong Canadian content — conjured up an idyllic and stress-free landscape romantically associated with Natives. With her skills of oratory and sense of drama, Johnson charmed audiences at home and abroad with her thrilling performances. Playing to the expectations of her audience, the poet dressed in buckskin clothing and silver trade brooches and feathers, thereby presenting as a stereotypical Indian maiden but one with true authenticity. In contrast, two infamous characters are renowned for carrying this playacting even further: Buffalo Child Long Lance and Grey Owl.

In person, Long Lance was a captivating example of chiseled manhood, complemented by his academic and athletic accomplishments at the Carlisle Indian Industrial School in Pennsylvania. Rather than accept a scholarship at West Point, the United States Military Academy, Long Lance chose, instead, to serve in the Canadian Army during the First World War. He later settled in Calgary as a journalist. Over the years, Long Lance had presented himself as a Cherokee; he then claimed to have been adopted by the Blood peoples, who gave him the name Buffalo Child.

Working initially as a packer and canoeman in the company of Native men, Belaney quickly learned to speak Ojibwa and was soon living with the Ojibwa on Bear Island, in Lake Temagami. Before long, he was adopted into the Ojibwa group as "he who walks by night," a name loosely translated as Grey Owl.

In his 1928 autobiography, *Long Lance*, however, Buffalo Child Long Lance introduces himself as a full-blooded Blackfoot and describes his early life on the Plains. The book was an instant success, and Long Lance toured the continent, lecturing and writing magazine articles about the plight of Native Americans. Two years later, he appeared as the character Baluk in *The Silent Enemy*, a film shot on Bear Island in Ontario, Canada, and costarring Molly Spotted Elk (Mary Alice Nelson). The movie would prove to be his undoing.

Another of Long Lance's costars in the movie was Sioux Chief Chauncey Yellow Robe, a descendant of Sitting Bull. Suspicious that Long Lance was not the person he claimed to be, Yellow Robe investigated his background, only to discover that Long Lance was, in fact, Sylvester Long, born in North Carolina of mixed ancestry. Long Lance could almost certainly claim to have Indian blood, but he also had black and white forebears. As it turned out, Long Lance had fabricated his autobiography using stories he'd heard from a friend. But before his fall from grace, Long Lance shared a message about the need for Natives to adapt to a changing world, one that was heard by many and resonated throughout much of North America.

The story of Grey Owl has a number of parallels. According to his biographer Lovatt Dickson, Archie Belaney, influenced by James Fenimore Cooper's writings, arrived in the Canadian wilds as a youth of 17, eager to become a woodsman and trapper. His half-breed heritage derived, apparently, from his Scottish father, who had been an Indian scout in the southwestern United States, and his Jicarilla Apache mother. Working initially as a packer and canoeman in the company of Native men, Belaney quickly learned to speak Ojibwa and was soon living with the Ojibwa on Bear Island, in Lake Temagami. Before long, he was adopted into the Ojibwa group as "he who walks by night," a name loosely translated as Grey Owl.

An adept woodsman and trapper, Grey Owl served in the First World War as a sniper and returned to the north woods of Canada lame and depressed. Gradually assuming his former life of trapping, he became more

Here, Grey Owl repairs an Ojibwa-style snowshoe. Although men traditionally made the wooden frame while women added the netting, a man was capable of doing the weaving or making repairs when necessary.

and more dissatisfied with taking the lives of animals. The turning point came when he rescued two orphaned beaver kits and raised them in his cabin. In 1931, Grey Owl emerged from the wilds with the manuscript for *The Men of the Last Frontier,* followed by his autobiography, *Pilgrims of the Wild,* in 1935, which became an instant best seller. Two more books, *The Adventures of Sajo and Her Beaver People* (1935) and *Tales of an Empty Cabin* (1936), that were intended for young readers captivated all ages.

Grey Owl carries a beaver kit on his shoulder — one of two that he raised in his cabin. Of English heritage, Archibald Stansfeld Belaney (later Grey Owl) promoted the image of the Natives as the original environmentalists.

Grey Owl's writing success pulled him into a heavy schedule on the lecture circuit, a move that proved fatal. He died in 1938, at the age of 49. Barely one week after his death, his true identity was revealed. Grey Owl had been raised as Archie Belaney in Hastings, England, by his paternal grandmother and two unmarried aunts. He had no Native American ancestors.

Even so, the public showed little concern about this deception. The power of Grey Owl's message buoyed his reputation, even after death. His

passion for preserving the wilderness awakened conservationists and inspired them to action. Author and historian Daniel Francis claims the modern greening of the First Nations began with Grey Owl. At the very least, we can credit Grey Owl with affirming, if not creating, the image of Natives as the original environmentalists.

Growing out of the Wild West shows, Boy Scouts, Lewis Henry Morgan's Iroquoianist club and myriad other role-playing groups, Indian hobbyists — or, as they prefer, "American Indianists" — have become firmly entrenched, primarily in Europe. While movies, literature and powwows continue to fuel this passive voyeurism, many Indianists would rather take an active part in a Native lifestyle. Whereas the Boy Scouts of America adapted Indian culture to its programs, amateur adult hobbyists have tried, instead, to replicate Native culture as authentically as possible.

Generally speaking, hobbyists emphasize the spirituality of their identification with Native Americans and express a somewhat idealized concern for the despoiling of the environment. On an individual basis, many hobbyists have been recognized for dressing in Native attire for portraits and costume parties. It is, however, the colorful performances of organized groups that are most apparent.

Once the railroad opened up the American West, exposure to the early exoticism of the Pueblo groups of the Southwest inspired hobbyists to re-create Snake Dances, albeit without the critical ingredient of Native spirituality. As reenactors became more serious, however, they found the permanent architecture and formalized ceremonies of the Southwest increasingly difficult to emulate. By contrast, the Plains tribal groups, which had emerged with the introduction of the horse, possessed more colorful displays, more fluid boundaries and a place for individualism. It is not surprising, then, that virtually all hobbyists, North American and European, prefer to embody the tribes of the Plains.

Hobbyism in Britain is reflected in the Grey Owl Society and the English Westerners' Society, both of which are active today. Some groups, such as the Sioux Indian Dancers' Club, have enjoyed only a brief flourish. Most of these hobbyists have shared their acquired knowledge of specific Native groups and ethnologies and have freely offered suggestions on how to replicate the material culture and where to obtain the necessary materials. Individual members have written books, articles and newsletters, erected displays, mounted exhibitions of their collections, presented materials to museums, contributed to the body of Native American studies and donated financially to education and instruction on Canadian reserves.

Greatly influenced in the past by Wild West shows and
the romanticized novels of Karl May, Germans continue to exhibit
the greatest fascination with playing Indian. The earliest record
of Germans dressing as Indians is in the late 19th century.

In Europe, Indian hobbyists remain active in Germany, Finland, Russia, Holland, Belgium, France, Italy, the Czech Republic, Slovakia, Poland and Switzerland. In addition to making their own costumes, writing articles, publishing magazines, performing Native dances and holding powwows, many of these groups try to support the Indian tribes of North America in some fashion. While they enjoy role-playing and re-creating traditional beaded garments and paraphernalia, they are fully aware of the issues plaguing the real Natives.

Greatly influenced in the past by Wild West shows and the romanticized novels of Karl May, Germans continue to exhibit the greatest fascination with playing Indian. The earliest record of Germans dressing as Indians is in the late 19th century. Organized hobbyist groups are documented as early as the 1910s in Frankfurt, Dresden and Munich. By adopting the personae of renowned Native peoples (most often the Sioux), studying their history and mastering ceremonial songs and dances, the hobbyists were prepared to entertain public audiences. The number of American Indianist groups in Germany continues to grow today, as does the membership of each.

On a scholarly level, innumerable universities across Europe, while emphatically not hobbyist institutions, offer Native American studies for scholars with a primary focus on Native literature. Other scholars do field research in America, and all are committed to disseminating their findings in print and at conferences held by, for example, the European Association of American Studies. In 1980, European museum curators gathered to discuss their institutions' collections of Native materials and the challenges they

FACING PAGE: *Nanuk and Tuktuk* by Nick Huard. Photograph by Jan Thijs. The dramatic use of backlighting unleashes the power of Nanuk and Tuktuk in Huard's haunting tribute to the polar bear and the caribou — the two kings of the Arctic.

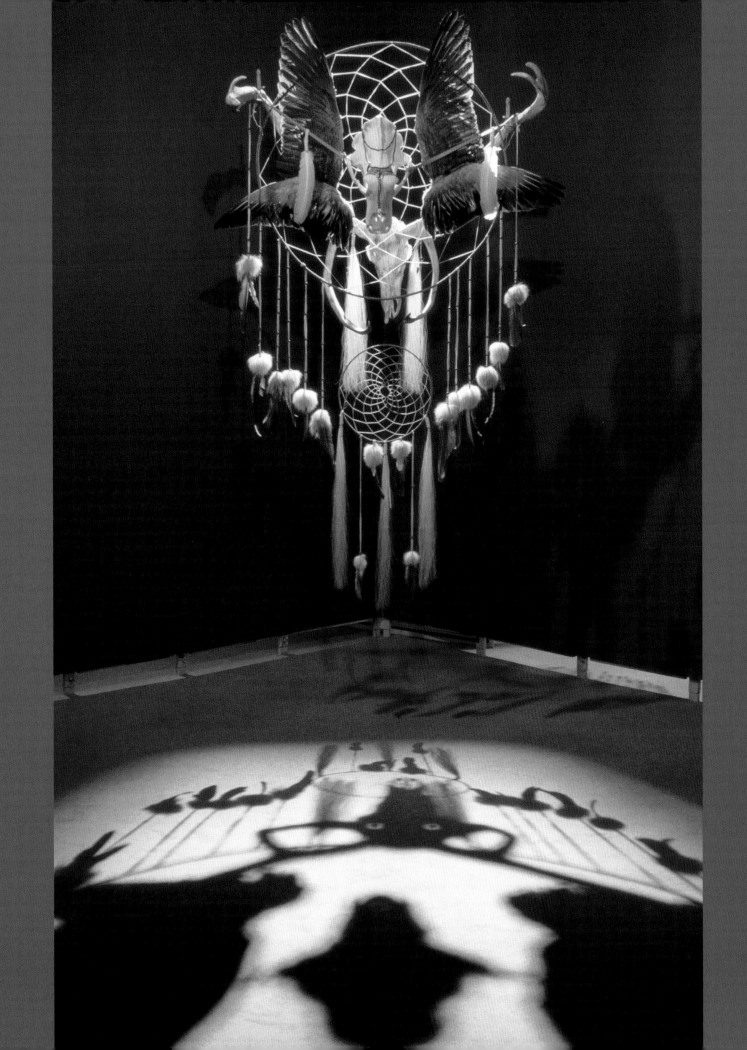

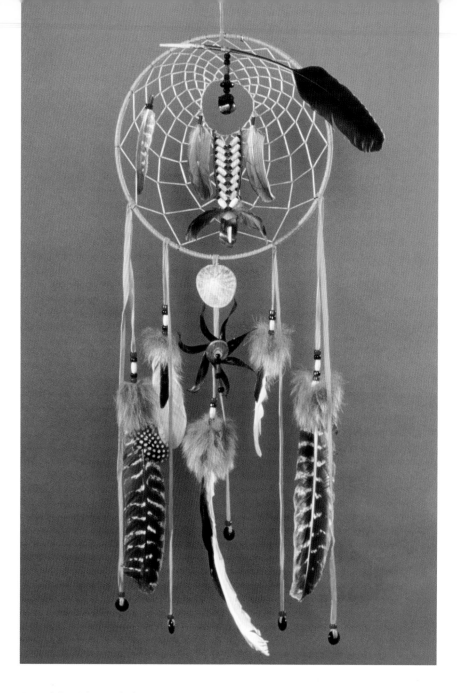

Cascade by Nick Huard. Photograph by Pierre Dury. Materials: Turkey vulture feathers, goose feathers, bones, sand dollar, glass beads, caribou babiche.

faced. Known as the American Indian Workshop, this loosely formed organization has expanded its focus over the years to include international scholars, Native Americans and interdisciplinary perspectives on various aspects of Natives and their culture. Several European museums and art galleries continue to mount exhibitions highlighting both heritage artifacts and pieces by contemporary Native artists. The European fascination with all things Native is alive and vibrant.

Known as the American Indian Workshop, this loosely formed organization has expanded its focus over the years to include international scholars, Native Americans and interdisciplinary perspectives on various aspects of Native culture.

Although it is not our intention here to promote New Age philosophy, it is necessary to acknowledge its influence in the presentation and acceptance of dream catchers in North America and beyond. This philosophy arose, in part, from a growing recognition that Indian beliefs and practices had much to offer non-Native North Americans. However, as religious historian Philip Jenkins demonstrates, the social and political stresses in the United States during the early 1960s and again in the late 1970s helped provide the essential context for understanding the emergence of the New Age movement.

Initially, many non-Natives who had embarked on a search for a religious fulfillment they were unable to find in Christianity eventually embraced the proponents of the New Age philosophy. That philosophy sought solace in the older and seemingly more spiritual religions and became a foundation of the American counterculture movement of the 1960s. By 1975, this movement had become a cultural and religious phenomenon in which Native culture and spirituality were central. Fed by hobbyism and proselytized by wannabe Indians, this movement led to the creation of rituals, ceremonies, healing practices, medicine wheels, literature, feminism, shamanism, Mother Earth, vision quests, Native-sounding names, tribal affiliations, power crystals, blended traditions and merchandise by non-Natives — all designed to provide the requisite spirituality.

These "authentic" new traditions are based on earlier Native traditions, albeit from an array of tribal sources. To Jenkins, the New Age has developed into a stereotype that has become a benevolent dream shaped by its consumers, which leads us directly to the dream catcher. Drawing from this rather brief description, it is clear that purchasing a dream catcher helps the buyer, in some way, to realize spirituality, receive solace and achieve personal dreams. And, as one encyclopedia of secret signs and symbols contends, the dream catcher is an essential part of the kit for any self-respecting New Ager.

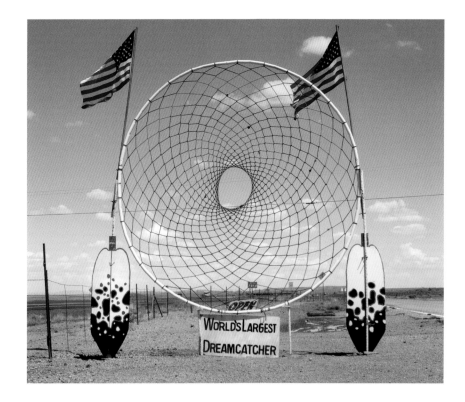

On the storied Route 66 near Meteor City, Arizona, this dream catcher, billed as the largest in the world, may just be big enough to catch all the dreams on Earth. From a marketing point of view, it successfully captures a large number of tourists.

MARKETING

A strong market in souvenirs developed hand in hand with the historical fascination with Native Americans and became intensified by both active and passive tourism (that is, the act of physical travel or the act of being part of a commercial audience). Quality was often not a priority, and Natives have been willing producers. The Wild West tours throughout Europe in the late 1880s were well advertised and offered authentic related merchandise for sale by local shopkeepers. Tourists visiting the American West and Southwest were eager to acquire mementos of their adventures. By contrast, powwows provided another venue for the exchange of goods between performers, tribal groups and non-Native members of the audience. Marketing New Age ideas and material items as "Indian" or as having come from a "Native" source projected the ideals of both authority

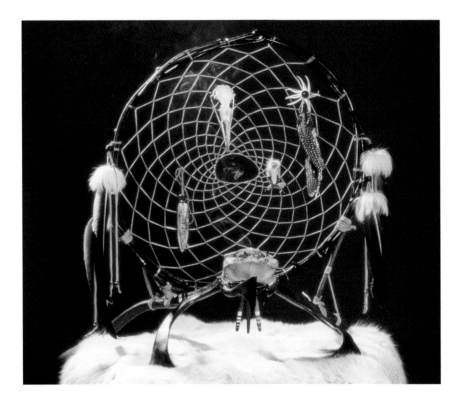

Altar by Nick Huard. Photograph by Jan Thijs. Materials: Egret skull, caribou skull, guinea hen feathers, Peary caribou fur, caribou antlers, glass beads, caribou babiche.

and antiquity while also characterizing the purchasers as spiritual consumers. Then came dream catchers.

As dream catchers became ubiquitous throughout North America, their acceptance, function and reproduction grew into a profitable non-Native marketing venture. By the early 1990s, a proliferation of items relating to dream catchers were on offer, most of them directed toward white consumers. Dream catchers and dream catcher imagery could be found just about everywhere. Mail-order catalogs from museums promoted Wanuskewin (Cree) Heritage Park, in Saskatchewan, and Native trading companies from Churchill, Manitoba, to Halifax, Nova Scotia, and all featured full-sized examples and smaller jewelry items.

One catalog even offered to make personalized dream catchers. Tourist outlets sold scarves, key chains, T-shirts emblazoned with the name of the location below a dream catcher image and dream catchers in a variety of sizes and colors and with a range of adornments. Original art, prints and cal-

endars featured dream catchers, often as the background. The Bradford Exchange in the United States, renowned for its numerous commemorative series, offered a selection of dream catchers rendered as sculptures, wall decor and mixed media.

Catalogs of craft companies likewise offered various do-it-yourself projects for eager enthusiasts. The Tandy Leather Factory promoted the purchase of kits by advertising that it would pay the postage on all orders. The long-standing Mary Maxim mail-order company offered cross-stitch kits of dream catchers with inspirational verses to embroider, suitable for framing. A verse in its Spring 2000 issue reads: "Take Time to Laugh, Take Time to Love, Take Time to Believe in the Promise of Your Dreams." The image of the dream catcher is a circle divided into four quadrants, then subdivided into four semidirections. Smaller dream catchers appear in each corner of the picture. The verse in a second kit is: "Walk Tall as the Trees, Live Strong as the Mountains, Be Gentle as the Spring Rains, Keep the Warmth of the Summer Sun in Your Heart." A circle — the

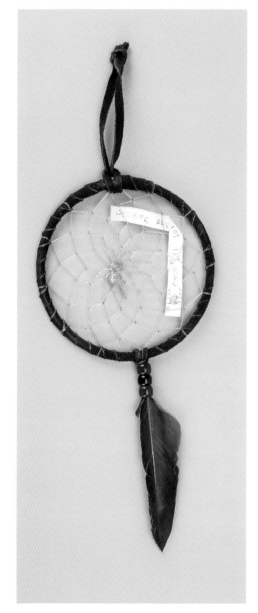

Housed at the Canadian Museum of Civilization as part of the Canadian Prime Ministerial Collection, this dream catcher was made by a Kahnawake Mohawk (Iroquois) and presented to Prime Minister Pierre Elliott Trudeau. The fragment of paper slipped into the netting affirms that ownership.

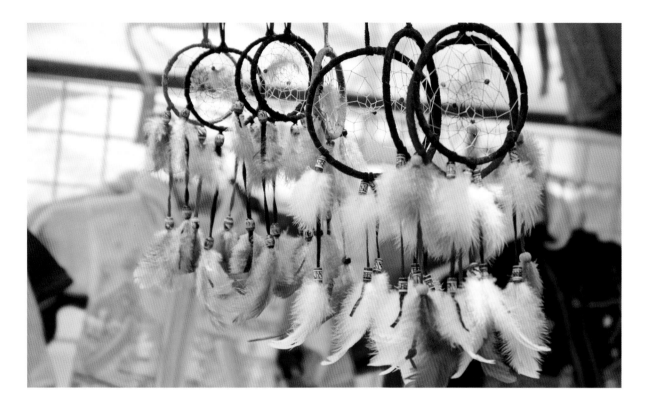

Masses of dream catchers, such as the lot shown here, can be found for sale at a variety of North American venues: powwows, Native craft outlets, tourist centers and museums. Similar displays can be seen throughout Southeast Asia and Australia.

dream catcher — surrounds the verse, and two smaller dream catchers sit on that circle. Embroidered feathers decorate all of them. Frames could be purchased separately.

During the 1990s, Mary Maxim produced several catalogs dedicated to dream catchers, offering cross-stitch kits that could be worked onto sweatshirts, greeting cards and even switch plates for light fixtures. Dream catcher kits with inspirational verses were available repeatedly from at least 1994, when they were featured on the front cover, until 2000. As interest in dream catchers began to wane over time, the kits were advertised farther and farther back on the catalog pages and the same designs were offered several times as sale items. No dream catchers appeared in the catalogs for 2001.

One dream catcher kit contained a five-inch (12.7 cm) metal ring, suede lacing, waxed linen thread (made and/or packaged in Taiwan), three stamped silver-colored metal tepee shapes, three different types of plastic pony beads,

With a dream catcher at its center, this 1995 promotional poster for the University of South Dakota was designed to appeal to Native American students. The promise? Education would prepare them for leadership roles. The poster reflects the popular blending of Native spirituality and non-Native meanings. For Natives, catching dreams is ultimately meant to benefit the entire community: Those who are protected from evil or illness are able to contribute to the well-being of others. For non-Natives, the theme of "catching dreams" is fundamentally focused on the desires and goals of the individual.

In a completely different media form,
a comic strip in 2004 featured a non-Native teacher
helping a Native class make dream catchers while she daydreams
about the "dreamy" man she hopes to catch.

six white feathers (bird species unspecified) and 12 pheasant feathers. The instructions were in both English and Spanish. On the reverse side of a card printed with the "Legend of the Dream Catcher" was this assurance: "These items were traditionally made from buffalo hides, eagle feathers, bone and furs. Today, the natural materials, such as suede, furs, leather and feathers, come solely as a by-product from domestic animals."

This list of "traditional" materials was clearly derived from Plains' sources, rather than the woodland-dwelling Ojibwa, the originators of the dream catcher. Yet the main point is clear: The materials included in these kits are environmentally and socially acceptable. Indeed, some makers feel that these new materials have an advantage over earlier materials, which tended to dry up and disintegrate fairly quickly. The metal hoops and synthetic sinew ensure a longer-lasting product.

The media, too, enthusiastically embraced the image of the dream catcher and its meaning. One newspaper article suggested that travelers who wish to experience a smooth journey should carry one of the "lucky charms" discussed. Among these was a dream catcher from Arizona. Another article focused on the irony of the presence of a dream catcher in the church office of an Anglican rector: It seems that neither the dream catcher nor the religious trappings held sufficient power to protect the office from being broken into and vandalized.

Typically, media stories heralded the healing properties of dream catchers. For example, a dream catcher figured prominently in the foreground of a picture that accompanied a news item about a teenage girl with cancer whose leg had been saved from amputation and whose dream to sail competitively restored. Another news story described how the gift of a dream catcher cured a man of recurring nightmares, allowing him to sleep soundly for the first time in months. Yet another reported a vehicle break-in; the only items stolen were a pair of sunglasses and a dream catcher.

The rampage in a Scottish school in 1996 that left 16 children and their

Books such as *Isaac's Dreamcatcher*, *Grandmother's Dreamcatcher* and *Dreamcatcher* (published by a Native-owned press in British Columbia) stress the connections between generations and the spiritual nature of dream catchers and include instructions on how to make your own.

teacher dead inspired a professional who treats traumatized children to send 700 healing packages to the school's surviving students. The therapeutic items in each package included a dream catcher so that each child might gain control over his or her dreams. Several Native groups in Alberta and British Columbia cooperated by making dream catchers to meet the daunting target number. The dream catchers proved to elicit the most positive responses from the troubled students.

In a completely different medium, a comic strip in 2004 featured a non-Native teacher helping a Native class make dream catchers while she daydreams about the "dreamy" man she hopes to catch.

And, presumably, the dream catcher purportedly chiseled onto a gravestone in another account was placed there to ensure a peaceful rest for the deceased. While these anecdotal stories concern individuals, they establish the degree to which non-Natives have adopted the symbolic power of these Native charms.

Dream catchers have, indeed, turned into a marketing phenomenon. The word itself has become a catchphrase used by publishers, wedding planners, bed-and-breakfast operators and hairdressers in reference to just about anything that calls upon a dream, a romantic vision or a goal or that alludes to Native spirituality. A wide variety of merchandise claiming to be "dream catchers" is available on the Internet. Among the many examples are Navajo area rugs, bed tents for children, purses, yoga pants, socks, boots, house flags, iPod skins and women's intimate apparel. Few, if any, of these items are made by Natives.

Several literary examples cover topics from actual dream catchers and Native mythology to alien invasions. For example, Stephen King's science fiction novel *Dreamcatcher* introduces aliens to a North American wilderness setting. *Dream Catchers: A Journey into Native American Spirituality* (1999) by John James Stewart is a compilation of stories from several First Nations. On the back cover, the endorsement likens the contents to dream catchers that

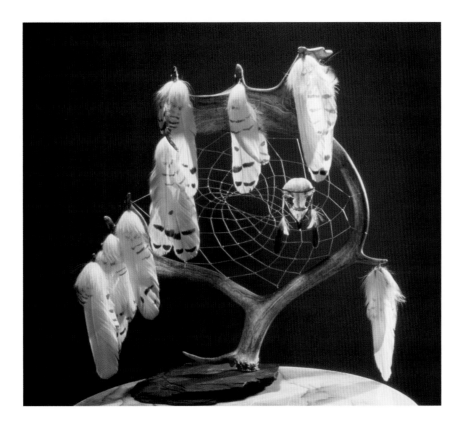

Snowy Owl by Nick Huard. Photograph by Jan Thijs. Materials: Snowy owl feathers, owl skull, caribou antlers, caribou babiche, slate.

enable you to remember the good dreams while disposing of the bad ones. The book has been assembled to help readers remember some of the best Native American stories.

A more scholarly book, *Dream Catchers: How Mainstream America Discovered Native Spirituality* (2004) by Philip Jenkins, provides a clear chronological overview of the changing views of non-Native attitudes toward Native spirituality and the increasing level of self-confidence exhibited by Natives in the United States. Several other books have dream catcher titles, including Margaret Salinger's *Dream Catcher*, a 2000 memoir about her father, J.D. Salinger. A handful of books that actually describe or explain the meaning of dream catchers fall into the genre of children's literature. Books such as *Isaac's Dreamcatcher*, *Grandmother's Dreamcatcher* and simply *Dreamcatcher* (published by a Native-owned press in British Columbia) stress the connections between generations and the spiritual nature of dream catchers and include instructions

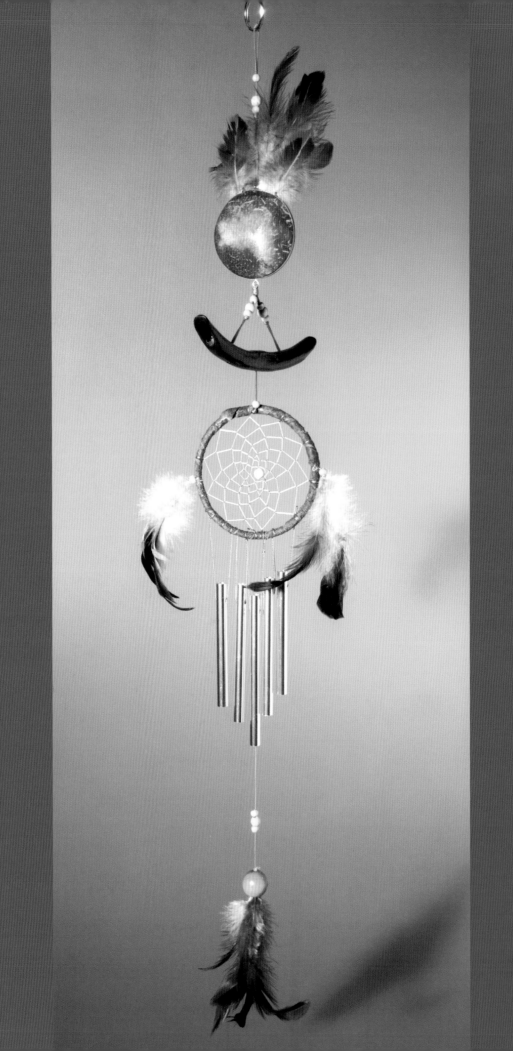

on how to make your own. Not to miss the trend, the 1999 movie version of Grey Owl's story, directed by Richard Attenborourgh, features a dream catcher about 12 inches (30.5 cm) in diameter that Grey Owl places outside his cabin, explaining to his Iroquoian bride that it is for babies and newlyweds. A scholarly journal from Europe shows a photograph of dozens of dream catchers for sale at a tourist venue. A tongue-in-cheek caption alluding to dreams and nightmares suggests that by purchasing these dream catchers, buyers will help keep Natives of the Navajo Nation employed.

An intriguing example of the blending of Native American spirituality with other religious beliefs is encapsulated in an object collected in Mongolia in 2004 and pictured on the facing page. Cataloged by the Museum of Archaeology and Anthropology, University of Cambridge, U.K., as an "instrument for catching evil spirits," it is, in effect, a North American dream catcher that has been incorporated into a Mongolian ritual artifact. The object is in the form of a mobile suspended from a metal ring. At the center is the dream catcher itself, constructed from a metal ring covered with a strip of hide and filled with a web of synthetic fiber threads. A natural-colored bead is at the center of the web. Two feathers are attached to each side of the ring, which is suspended from a piece of bone that has been painted brown. This, in turn, is suspended from a disk, possibly made from a polished coconut shell. Feathers protrude from the top of the disk.

Suspended from the ring at the center of the object are five metal tubes akin to wind chimes. Several feathers hang from the central tube. All the elements are attached with yellow synthetic thread adorned with wooden beads. No further information is included in the museum records. It would be of interest to know where the maker obtained the dream catcher itself, whether or not the meaning of the dream catcher was transferred to this newly produced object and the nature of the symbolic meaning that the other materials hold in Mongolian culture. Did the added value rest with the incorporation of exotic materials, as recognized by anthropologists elsewhere in traditional shamanic art? Lacking the intent of the maker, we may never know.

Reflecting the parameters of the New Age movement, several Canadian websites advertise dream catchers that have been handcrafted in limited quan-

FACING PAGE: Collected in Mongolia, this dream catcher raises many questions. What meaning did it hold in Mongolian culture? Was the Native American symbolism simply adopted along with the form? Is it valued for its exoticism?

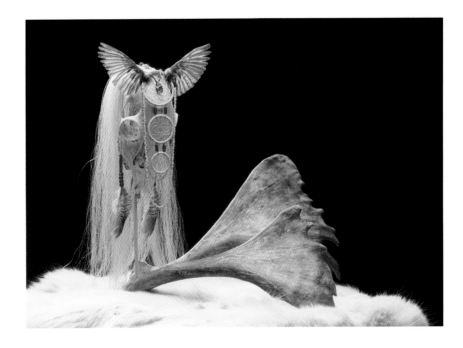

Mother Nature by Nick Huard. Photograph by Jan Thijs. Materials: Deer skull, sparrow wings, turquoise, horse mane, glass beads, caribou antlers, Peary caribou hide.

tities by named individuals who claim to have been taught by their grandmothers from named First Nations reserves — reserves that may or may not exist. A few individuals confide that the dream catcher designs and their teachings were given to them directly from the Great Spirit. Without delving into the veracity of these claims and the authenticity of the claimants, the significance rests in the materials used in the dream catchers and the meanings provided.

The hoop can be formed into a sacred circle with no beginning or end or into a raindrop shape representing the raindrops that fall to create rivers and, ultimately, the ocean, which in turn represents the next generation. Feathers provide a conduit for the good dreams to reach the dreamer. Particular gemstones or crystals renowned for their healing properties can be incorporated, often suspended in the middle of the netting. Turquoise relieves stress, joins love with the wisdom of basic truth, promotes communication and provides a connection to the spirit world. Tigereye, a metamorphic stone, is understood to balance emotions and enhance clear perception and insight. An amethyst crystal brings pleasant dreams, spiritual development and purity. Aventurine, a form of quartz, is an all-purpose healer that reduces stress and enables the owner to become more spiritual and independent. Other healing

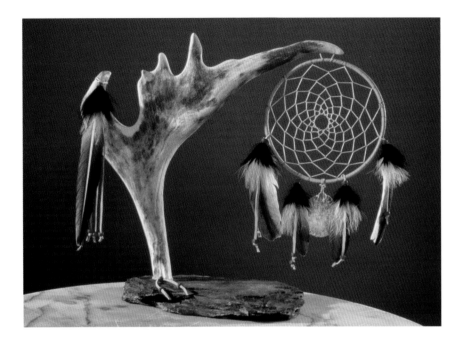

Caribou Hand by Nick Huard. Photograph by Pierre Dury. Materials: Caribou antler, rabbit fur, seashell, goose feathers, glass beads, caribou babiche, slate.

stones with specific spiritual qualities include rose quartz, moonstone and hematite. Very few of these gemstones are indigenous to Canada.

These website offerings also introduce a myriad of titles for a large number of design variations. Spirals, circles within circles, multiple hoops, butterflies and simple spiderweblike dream catchers elicit such names as Many Dreams; Sun and Moon; Pentacle; Two Paths/One Journey; Bud of the Rose; and Soaring.

According to one site, dream catchers are wisdom teachers — all you have to do is listen. These are clearly New Age items. But sometimes it's difficult to assign a New Age or a legitimate Native claim to the production of these items. The recognizable features of a particular maker of Apache dream catchers, for instance, clearly identify her Native heritage. Honoring the teachings of her mother, this Apache artist also offers crystals, dream pillows filled with ingredients from a family recipe to ensure wisdom and knowledge and Full Moon and New Moon Herbs. Can advertising such as this be considered a New Age resource, or should it be regarded simply as a marketing ploy to attract customers?

The inclusion of Eastern philosophies within New Age concepts can

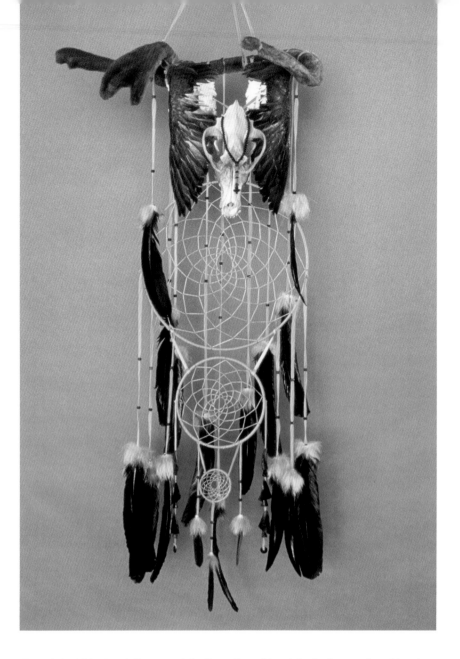

Cascade by Nick Huard. Photograph by Pierre Dury. Materials: Caribou antler with velvet, mallard duck wings, crow feathers, wolf skull, Arctic wolf fur, glass beads, caribou babiche.

be discerned in a dream catcher made with a metal hoop wrapped in black thread and webbed half in black thread and half in white. A black and white glass yin-yang symbol is suspended in the center, and a silver spiral charm etched with the words "Follow Your Dreams" is attached to the white ribbon provided for hanging. Yin and yang are complementary opposites within a greater whole, constantly interacting and never existing in absolute stasis. Thus this dream catcher is marketed as the perfect model for anyone looking for balance in life. Meanwhile, a source in Japan sells cell-phone straps equipped with both dream catchers *and* feng shui beads — not only will

they catch your dreams, but they will also bring you good luck. Such New Age merchandise promotes otherness and a particular mystique. Even the pagan Wiccans get into the act, selling dream catchers that feature a "fierce eastern dragon" with its tail wrapped around a pentagram, the Wiccan symbol of faith.

Another website packages both Ojibwa and Lakota Sioux legends and medicine wheel teachings with each dream catcher purchased. The wholeness and harmony inherent in the circle of the hoop are meant to establish connections to the past, the present and the future. The four directions depicted in color on these medicine wheel dream catchers represent spiritual gifts. From the east come the gifts of the eagle, the color yellow, childhood, spring, dreams and visions. The south is associated with the color red, the earth, summer, love, trust and nourishment, while the west is represented by the color black, adulthood, autumn, introspection and healing. The north is the color white, elderhood, water, winter and wisdom. It must be noted that the qualities suggested here vary in accordance to which rendition is being promoted.

Authentic Native American dream catchers are handcrafted by members of the pseudo-tribe Little Shell Pembina Band. An array of shapes are constructed from natural twigs found wherever the maker happens to be. No information is provided about the other materials incorporated in the dream catchers, but significantly, each finished piece is cleansed with sage gathered from a site in California long regarded as sacred by Native Americans and now considered to be a New Age sacred site. The protective powers innate to dream catchers are as valid and as effective as the faith of the owner.

ARTISTS AND MANUFACTURERS

Since the beginning of the 21st century, dream catchers have grown into a worldwide marketing venture. Mass-produced dream catchers are available virtually everywhere. Search the Internet, and you will find an overwhelming selection based on size, shape, materials, techniques and attachments.

One American site offers a one-of-a-kind dream catcher that features a Seminole weave, with the netting offset to one side. There is also a snowshoe shape that suggests a teardrop, with netting only in the lower portion; and a Cherokee-style willow dream catcher is simply a netted teardrop. The Soul Connection double dream catcher has two overlapping hoops with the cen-

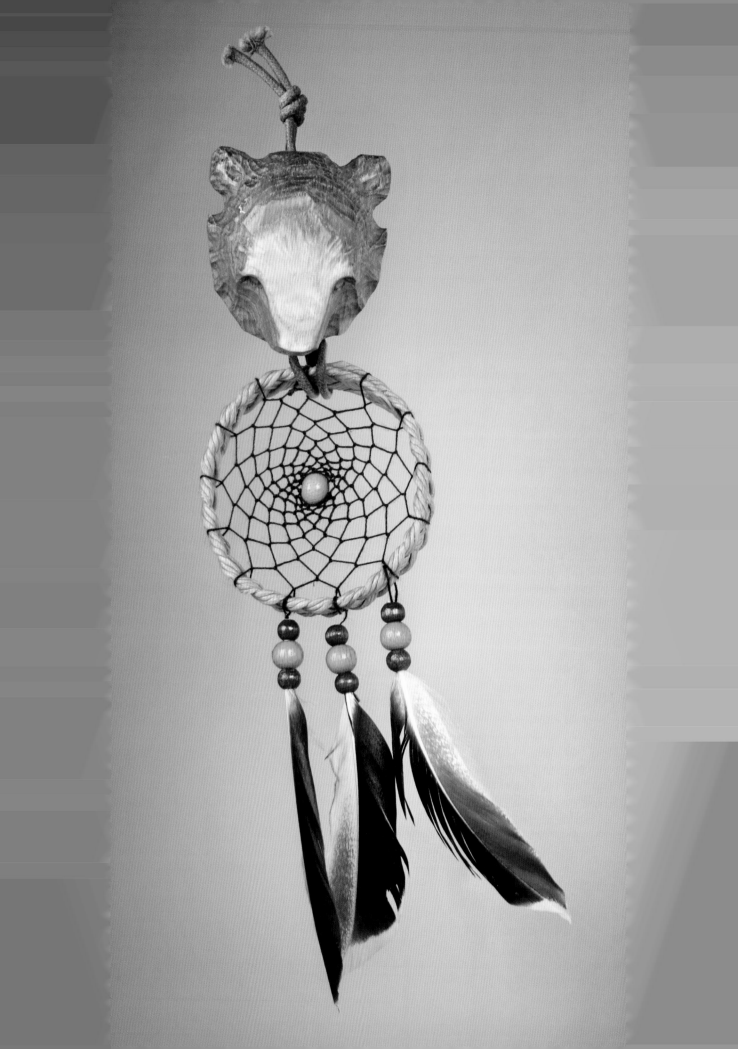

tral area free of any netting. In the Natural Generations dream catcher, there are three or five incrementally sized netted hoops, with the largest at the top and the others suspended one from the other. The Inukshuk dream catcher has a miniature Inuit inukshuk suspended from the bottom of a netted hoop. Spirals, double spirals, diamonds and even heart-shaped pieces demonstrate just how far the design has strayed from the traditional round hoop.

These items are available in a number of sizes and colors with attachments ranging from feathers, beads, shells and spirit chimes to small effigies of bears and turtles and hoops that are formed from wood, vines or twigs. The prices cover an equally wide range. In other words, this site offers something to please the most discerning consumer. Dream catcher jewelry in the form of earrings and necklaces introduce more variations in materials. The only detail not always disclosed is the identity of the maker.

Internationally, dream catchers are available in several European countries and in Indonesia, Mongolia, Australia, South Africa, Japan, Thailand and China. A number of companies in Asia and Southeast Asia offer a wide selection of dream catchers at affordable prices for export to other countries. At least five businesses in Bali, Indonesia, produce large numbers of dream catchers for export to India, China, Nepal, Thailand, Southeast Asia, Canada, the United States and Europe. Guaranteed to be handwoven, they are produced with chicken feathers, leather, beads, root and string.

Apparently, these and other unspecified materials are treated, boiled and dyed repeatedly to ensure that the dream catchers are both safe and beautiful. Two of these Balinese companies also retail more expensive versions, including a black one with a silver web decorated with beads, cowrie shells and feathers. The Fair Trade Shop insists that the dream catchers it markets are "lovingly made on the beautiful Island of Bali by craftspeople who are properly rewarded for their endeavors."

A Japanese company offers men's rhodium-plated necklaces, each with a turquoise bead and silver feathers. The Japanese fascination with dream catchers extends to the development of artistic images suitable for tattooing. Most are intended to have the netted hoop placed on the upper arm and

FACING PAGE: A handcrafted dream catcher from the Japanese island of Hokkaido. The local adaptation of this Native American object is clearly reflected in the materials used: braided straw for the hoop, thread netting, wooden beads, duck feathers and a bear's head carved from wood. An Ainu family has been making dream catchers for the tourist market and Japanese residents since 1998.

shoulder with either feathers and/or beads on thongs suspended below. This obsession with dream catchers and the potential of dream catchers as a marketable tourist item have driven the Japanese to import them from Bali to satisfy both markets.

In the Teshikaga area of the Japanese island of Hokkaido, at least one Ainu family has been making dream catchers for the tourist trade since 1998. A dream catcher that was personally collected in Japan by two Canadian museum curators is artist-made with a braided straw hoop and thread netting. Suspended from a bear's head that has been hand-carved from wood, it is finished with three pendants of wooden beads and three duck feathers attached to the bottom of the hoop. Large displays of dream catchers that the curators observed in other shops had been imported from Bali.

Many of the dream catchers available in the retail markets of North America are imported from China. As one Native shopkeeper was quick to point out, Native craftspeople cannot produce the quantities required nor can their dream catchers be sold at a price that will recompense the maker adequately, cover the shop's overhead and please the purchaser. In 2011, one Chinese company alone claimed to have produced 500,000 pieces a month. Of course, China is also supplying Australia and possibly other countries. When elaborate Chinese-made dream catchers can be purchased online for less than one dollar, it is easy to see how the potential for quick profit drives this particular market.

A more comprehensive evaluation of the worldwide manufacture, distribution and sale of dream catchers would be necessary to provide an accurate picture of the market's magnitude and to determine just who is buying and why. Are people in these locations buying dream catchers for themselves or are visitors to those areas purchasing them? Are these items being acquired by both residents and tourists? Does their presence in such diverse locations reflect a global fascination with Native American cultures?

THE FUTURE

The earlier discussion of net baby charms was based primarily on those being housed in museum collections. As they were collected by non-Natives, particularly by anthropologists who worked among the Anishinaabeg and Crees, the context and function of these items have been drawn from their ethnographic accounts. Will we be able to do the same with dream catchers? What position do museums take with regard to collecting dream catchers? A brief questionnaire e-mailed to a few museums in Britain

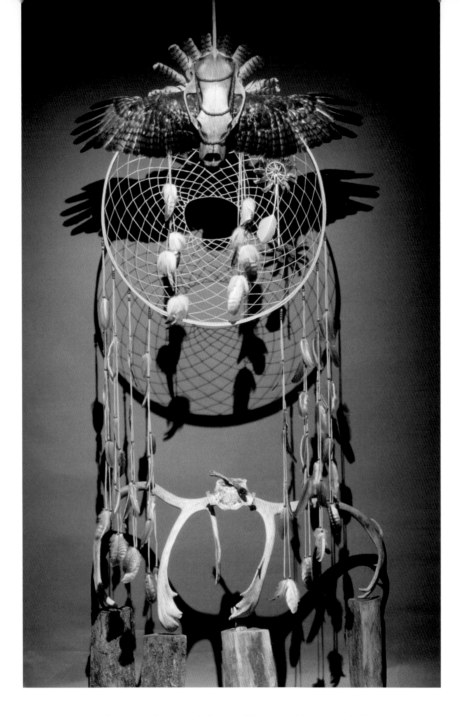

Altar No. 2 by Nick Huard. Photograph by Jan Thijs. Materials: Red-tailed hawk wings and feathers, polar bear skull, caribou skull and antlers, glass beads, caribou babiche.

and North America elicited some interesting feedback. Most of the museums we contacted do not have any dream catchers in their collections, primarily because they tend to collect passively; that is, they rely on donations of objects.

Generally, museum staff expressed feelings of indecision about collecting dream catchers. Some individuals were adamant about acquiring examples; others were less positive. For the most part, the dream catcher is perceived to

be a tourist item, made to sell to a non-Native market and purchased by visitors, teenagers and so-called spiritual practitioners, or New Age practitioners.

However, staff members are also aware that authentic pieces made by indigenous artists, even if they are unsure of the item's origin, use or maker, are acquisition-worthy. Some of the museums that have not been offered dream catchers have not yet devised an approach for acquiring these items. One curator indicated that the museum would add dream catchers to its collection if the items had a direct local connection. Another would collect them as craft pieces if they were made by an identified maker (not necessarily a known artist) from a recognized ethnic group and were of good quality.

Certainly, the major concern for documented authenticity continues to be a key determining factor. Even the authenticity can be questioned, depending on the knowledge of the curator. In one instance, a museum spokesperson stated that the museum would collect only Ojibwa dream catchers, as the Ojibwa are considered to be the originators. Pieces created by Native artists were deemed acceptable, while commercially assembled examples from such suppliers as China or Taiwan were unacceptable. A well-provenanced acquisition such as the dream catcher made by Clifford Crane Bear of the Blackfoot Confederacy (described on page 78) would encourage curators to acquire one for their museums.

Some curators, especially in smaller museums, stated that they are ill-equipped to provide the care necessary in handling a sacred object such as a dream catcher. In contrast, other curators, including some Native curators, felt that dream catchers are kitsch and not worthy of collecting. A thoughtful response from one Anishinaabe director acknowledged that his personal view of dream catchers as being merely tourist kitsch had changed with exposure to numerous older museum pieces, which, at the time they were collected, were themselves tourist items. Provided the dream catcher could be documented as to artist, date, location and ethnicity, said the director, it would be collected as a representation of a particular period of time.

Sales in large museum shops are often managed by retail staff and do not necessarily reflect the considerations and concerns of the curatorial staff. In fact, many curators actively discourage carrying dream catchers in museum shops, as their ready availability in other venues inhibits prospective sales. Even so, several do stock them. Small museums tend not to sell dream catchers, and at least one refrains from doing so as it is relatively close to a Native community that has a retail outlet.

Craft workshops that instruct non-Natives in the making of dream catchers have ramifications for their study as Native items. From an anthro-

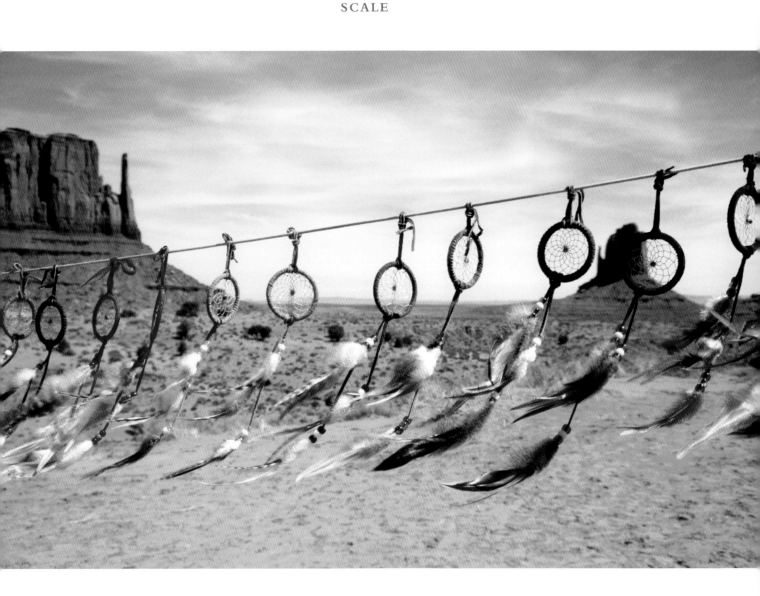

Blowing in the desert breeze in Arizona's Monument Valley, these Navajo dream catchers appear to magically span the gap between the West Mitten Butte on the left and the East Mitten Butte on the right.

pological perspective, the dissemination of skills and cultural values has implications with respect to the spread of material objects and the incorporation of visual and ideological concepts. In March 1995, the Canadian Embassy invited artist Nick Huard to travel to Caracas, Venezuela, as a visiting artist from Quebec. While there, he gave a workshop on making dream catchers, recounting the common legend of their origin, detailing the symbolic sig-

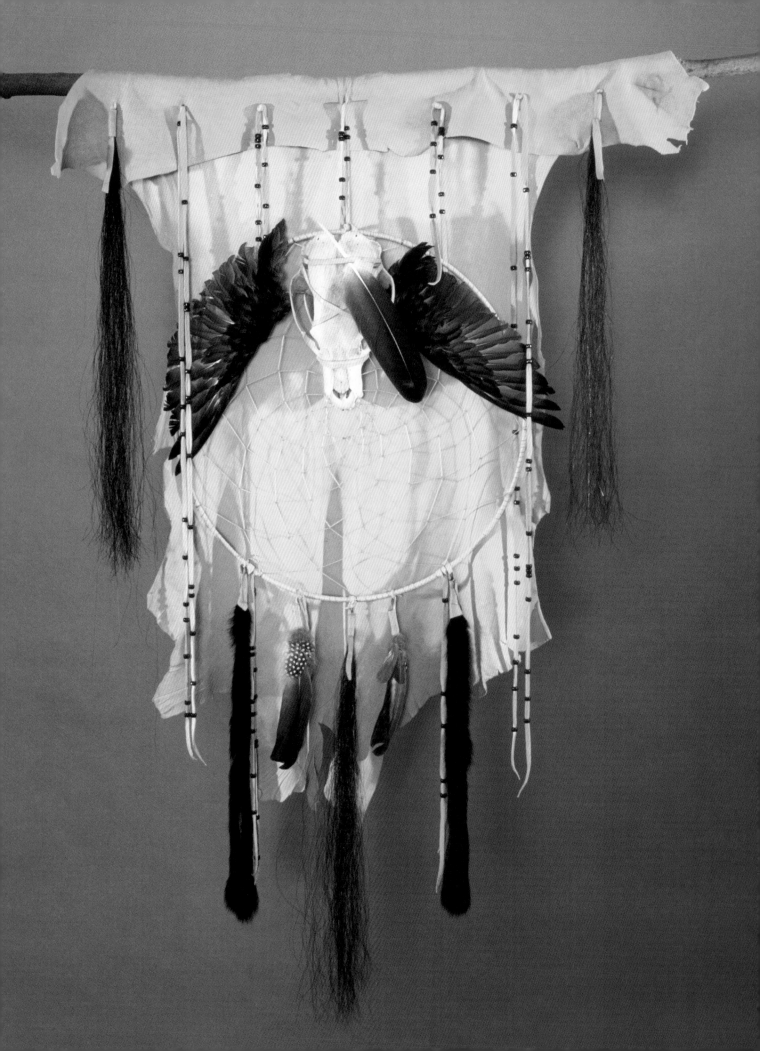

One issue that has not been raised so far in any information pertaining to dream catchers revolves around identity and appropriation — or misappropriation, if you will — of Native expression.

nificance of each material and element used and teaching the techniques of construction, first by demonstrating and then by overseeing.

Huard's workshop in Venezuela was followed by several sponsored by a Montreal museum and directed toward non-Native children. Other museums are understandably cautious about offering museum-sponsored workshops and stress that such programs must be developed carefully to handle the potential perceptions or misconceptions about exactly what the participants are making. As the public perceptions of dream catchers vary considerably, it is believed that there should be an emphasis on learning about Native cultures and what these material objects mean to Natives. The ethics of teaching others — whether the instructor is Native or not — becomes a multilayered learning experience.

Concern has been voiced that workshops presented by non-Native instructors are merely teaching a craft without instilling a sense of the dream catcher's meaning. Online and hobbyist magazines are little better, although they occasionally provide information about the natural materials incorporated. According to one online site, the making of dream catchers is a craft that can be quickly learned and does not require the mastery that beading or weaving does. Because of the simplicity of its assembly, the dream catcher is easily accessible everywhere. In contrast, another site offers spiritual lessons as you create your own dream catcher. You are instructed to consider the materials as you weave, to remember the plants of Mother Earth as you handle the wooden twig for the hoop, the rocks and water as you add semiprecious gems and the winged ones as you use their feathers. The fine thread in the knotted web is to be remembered as the thread that connects all of us. Finally, after suggesting further steps in your meditation, instructions and tips for making the dream catcher are provided.

One issue that has not been raised so far in any information pertaining

FACING PAGE: *Dear Deer* by Nick Huard. Photograph by Pierre Dury. Materials: Deer skin, horse mane, timber wolf skull, merganser duck wings, rabbit fur, glass beads, caribou babiche.

to dream catchers revolves around identity and appropriation — or misappropriation, if you will — of Native expression. Yes, dream catchers appear to be recognized as a Native North American item of material culture, and the revived origins have been credited to the Ojibwa. But they are being produced by Native groups other than the Ojibwa, and they are also being mass-produced outside of North America in Asian locations. Can all of these legitimately be sold as Native dream catchers? Does it matter?

In a March 2005 ruling in the United States, a judge upheld the rights of non-Indians to make Indian jewelry by declaring that a non-Indian who designs jewelry to look like jewelry made by Indians is free to advertise the similarity but that he or she must refrain from using the word "Indian" to describe the pieces so that customers are not confused. This judgment may have had some bearing on the current advertising of other Native Americans who have revised their promotional material to acknowledge that the Ojibwa are the originators of the dream catcher.

The Indian Arts and Crafts Act of 1990 is a truth-in-advertising law that prohibits misrepresentation in the marketing of Indian arts and crafts products within the United States. It is illegal to offer or display for sale or to sell any art or craft product in a manner that falsely suggests it is Indian-produced, an Indian product or the product of a particular Indian or Indian tribe or Indian arts and crafts organization resident within the United States. In Canada, replication remains a gray area that has not been addressed overtly. The reasoning behind this more relaxed attitude may rest with the positive ramifications that the development of the dream catcher as a pan-Indian phenomenon has had in establishing Native unity and solidarity while disseminating Native spirituality to non-Natives.

A long-term study in Japan that began in the early 1990s has documented an increase in desire for Native American items, an increase in the number of wholesale and retail outlets and a concomitant increase in the production of fakes not made by Native Americans. Although the study focuses on Hopi jewelry, it is pertinent to the buying and selling of dream catchers, especially in and by Asian markets. Sparked by the media, a craze for anything Native American quickly spread among young Japanese. Fueled by popular Japanese actors and singers who appeared on television wearing

An Ojibwa woman carries her doll "grandchild" in a *tikanagan*, or cradle board, on her back during a reenactment of the Hiawatha Pageant in Sault Ste. Marie, Ontario. For many years, this pageant was produced for the benefit of non-Native tourists.

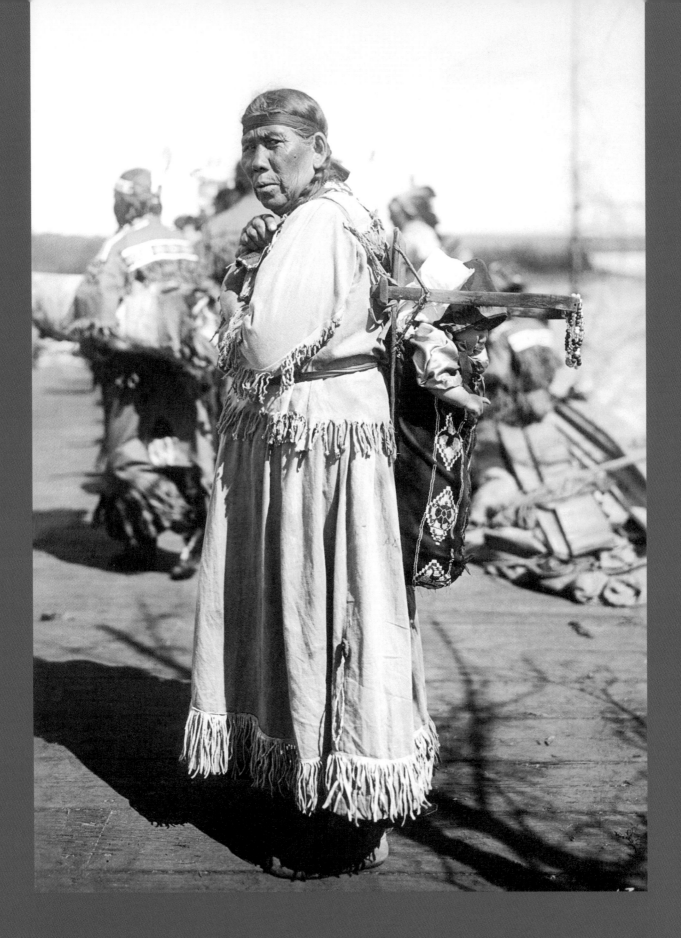

Native American jewelry, coupled with the screening of the movie *Dances with Wolves* in Japan, the growing demand for these products did not require that the place of origin be specified.

While higher-end merchandise was being purchased directly from artists in the American Southwest, the majority of purchasers were unconcerned or unwilling to pay the correspondingly higher prices. This stimulated the appearance of "misrepresented goods" on the market, and consumers were willing to accept vendors' claims of authenticity. As a result, non-Native-made items produced in Asia, Latin America and even the United States were displayed and sold as authentic Native-made. There is no legal definition in Japan to distinguish genuine from fake, so the retailers who dealt in genuine items were compelled to develop new marketing strategies to guarantee the authenticity of their Native American goods.

In recounting his experiences, enjoyed jointly with his cousin, to create and sell what he calls "pseudo-Ojibway" walking staffs, Ojibwa author Drew Hayden Taylor divulges two prophetic and applicable insights about the merchandising of Native "art." The first is that "many people will buy something if it appears to be an artifact of someone else's culture." The second is that "the marketplace can be fickle." Once he and his cousin had saturated the market, Taylor confesses that their walking staffs joined the club of Pet Rocks, bell-bottoms and mullets. The concern over market saturation is echoed by the author of the Japanese study, who suggests it is quite likely that 15 years is sufficient to flood a market with imitations.

On the surface, this appears not to bode well for the future of dream catchers or, at least, for the future of mass-produced dream catchers. But as non-Natives are unlikely to lose their fascination with Natives or Native spirituality any time soon and as artistic expression among the Native peoples remains an enduring and strong presence, Native-made dream catchers will continue to be produced.

For Natives, the embedded meaning of dream catchers will always resonate, and Native artists will feature dream catchers as the body and soul of their art. And non-Natives will continue to acquire dream catchers for a multiplicity of reasons: as gifts to be given or received, as a cure for bad dreams or poor health, as an icon of Native spirituality and as mementos of encounters with Native groups or special trips.

In the end, it is neither the shape nor the materials used in contemporary dream catchers that are a critical factor. Rather, it is the spiritual power of the netting, constructed as it is of lines and knots, and the owner's faith in that power which will prove to have lasting significance. Happy Dreams!

About the Artist

NICK HUARD

Many of the dream catchers pictured in this book were created by artist Nick Huard, who now resides in Kahnawake, outside of Montreal, Quebec. Born in Restigouche to the Bear Clan, Huard spent his childhood on the Mi'kmaq reservation on Gaspésie. Following years of residential schooling, he attended Collège Bourget in Rigaud, Quebec. Since 1988, he has worked as a documentary filmmaker. He has also worked as a photographer, a train conductor and a sound technician for CBS, CBC/Radio-Canada, TSN and NBC. Huard inherited a deep respect for his culture and the environment from his grandfather, a saddler and shoemaker, and his father, a master cabinetmaker. He has been making dream catchers since 1990 and has a permanent exhibit at the Red Cedar Gallery in Montreal. His dream catchers are also available at the McCord Museum Boutique in Montreal and the Galerie St-Merri in Paris. Huard is a member of the Conseil de la Sculpture du Québec.

Huard finds his dream catcher materials in his own backyard, so to speak, but he also gathers stones, feathers, beaks, antlers and animal skulls, both small and large, on more wide-ranging journeys across the continent. In an eloquent testament to the artist's reverence for the natural world, every piece is recovered from nature and recycled. Whether he is interpreting the calamitous consequences for the caribou after Hydro-Québec's flooding of La Grande Rivière, as he does in *The Little Girl of Kanaaupscow* (page 44), or nature's cycle of life, Huard honors the wild animals that are part of his world. No creature has been killed or mutilated to appear in his art.

Bibliography

Adams, Gary. "Art and Archaeology at York Factory." *The Beaver*, Outfit 313.1 (Summer, 1982), 38-42.

Ahenakew, Rev. E. "Cree Trickster Tales." *Journal of American Folk-Lore* 42 (1929): 309-353.

Alva, Walter. "New Tomb of Royal Splendor: The Moche of Ancient Peru." *National Geographic*, Vol. 177, No 6 (1990).

Atwood, Margaret. *Strange Things: The Malevolent North in Canadian Literature.* New York: University of Oxford Press, 1995.

Beaudet, Christiane. "Mes mocassins, ton canot, nos raquettes: la division sexuelle du travail et la transmission des connaissances chez les montagnais de la Romaine." *Recherches amérindiennes au Québec,* 14, 3 (1984): 37-44.

Benedict, Ruth Fulton. *The Concept of the Guardian Spirit in North America.* Menasha, Wisconsin: The Collegiate Press, 1923.

Berens, William. *Memories, Myths and Dreams of an Ojibwe Leader: William Berens as told to A. Irving Hallowell.* Edited with introductions by Jennifer S. H. Brown and Susan Elaine Gray. Montreal and Kingston: McGill-Queen's University Press, 2009.

Berkhofer, Robert F. *The White Man's Indian.* Toronto: Random House, 1979.

Bird, Louis. *Telling Our Stories: Omushkego Legends & Histories from Hudson Bay.* Peterborough, Ontario: Broadview Press, 2005.

Brightman, Robert. *Acoohkiwina and Acimowina: Traditional Narratives of the Rock Cree Indians.* Mercury Series. Ottawa: National Museums of Canada, 1989.

Brown, Jennifer S. H. and Robert Brightman. *The Orders of the Dreamed: George Nelson on Cree and Northern Ojibwa Religion and Myth, 1823.* Winnipeg: University of Manitoba Press, 1988.

Burkhart, Louise M. *The Slippery Earth.* Tucson: University of Arizona Press, 1989.

Calahasen, Stella. *Dream Catcher.* Penticton Indian Reserve, B.C.: Theytus Books, 2009.

Caldwell, J. Paul, M.D. *Sleep.* Toronto: Key Porter Books, 1995.

Coatsworth, Emerson S. *The Indians of Quetico.* Toronto: University of Toronto Press, 1957.

Coleman, Sister Bernard. *Decorative Designs of the Ojibwa of Northern Minnesota.* Washington, D.C.: The Catholic University of America, 1947.

Cresswell, J. R. "Folk-Tales of the Swampy Cree of Northern Manitoba." *Journal of American Folk-Lore* 36 (1923): 404-406.

Culin, Stewart. *Games of the North American Indians.* New York: Dover Publications, 1975 [first published in 1907].

Cushing, Frank H. "Outlines of Zuni Creation Myths," in *Thirteenth Annual Report of the Bureau of Ethnology, 1891-1892* (1896): 321-447.

Densmore, Frances. *Chippewa Customs.* St. Paul, Minnesota: Minnesota Historical Society Press, 1979 [first published in 1929].

Dickson, Lovatt. *Wilderness Man: The Strange Story of Grey Owl.* Toronto: The Macmillan Company, 1973.

Dumarest, Father Noel. "Notes on Cochiti, New Mexico." *American Anthropological Association Memoirs* 6, Part 3 (1905).

Ellis, Douglas C. "Now, then, still another story –," in *Literature of the Western James Bay Cree: Content and Structure.* Winnipeg: Voices of Rupert's Land, 1989.

——————. *Cree Legends and Narratives from the West Coast of James Bay.* Winnipeg: The University of Manitoba Press, 1995.

Engler, Mark. "Dream Catchers." *The Indian Trader* 26,10 (1995): 15-18.

Farmer, Bonnie. *Isaac's Dreamcatcher.* Montreal: Lobster Press, 2001.

Feest, Christian F. *Native Arts of North America.* London: Thames and Hudson, 1980.

Feest, Christian F., ed. *Indians and Europe: An Interdisciplinary Collection of Essays.* Aachen, West Germany: Edition Herodot, Rader Verlag, 1987.

Flannery, Regina. "The Cultural Position of the Spanish River Indians." *Primitive Man* 13, 3 (1940): 1-25.

——————. "Infancy and Childhood among the Indians of the East Coast of James Bay." *Anthropos* 57 (1962): 475-482.

Flannery, Regina and Mary Elizabeth Chambers. "Each Man Has His Own Friends: The Role of Dream Visitors in Traditional East Cree Belief and Practice." *Arctic Anthropology* 22, 1 (1985): 1-22.

Francis, Daniel. *The Imaginary Indian: The Image of the Indian in Canadian Culture.* Vancouver, B.C.: Arsenal Pulp Press, 1992.

Franco, José Luis. "Snares and Traps in Codex Madrid." *Notes on Middle American Archaeology and Ethnology*, No. 121 (1954): 53-58.

Graburn, Nelson H.H., ed. *Ethnic and Tourist Arts: Cultural Expressions from the Fourth World*. Berkeley: University of California Press, 1976.

Gray, Charlotte. *Flint & Feather: The Times of E. Pauline Johnson, Tekahionwake*. Toronto: HarperCollins Publishers, 2002.

Green, Rayna. "The Tribe Called Wannabee: Playing Indian in America and Europe," *Folklore* 99, No. 1 (1988): 30-55.

Hail, Barbara A. "I Saw These Things": The Victorian Collection of Emma Shaw Colcleugh, *Arctic Anthropology*, Vol. 28, Issue 1 (1991): 16-33.

Hallowell, A. Irving. "Ojibwa Ontology, Behavior and World View," in *Culture in History: Essays in Honor of Paul Radin*, edited by Stanley Diamond, 19-52. New York: Columbia University Press, 1960.

——————. *The Ojibwa of Berens River*. Toronto: Harcourt et al., 1991.

Hyde, Lewis. *Trickster Makes This World*. New York: North Point Press, 1998.

Irwin, Lee. *The Dream Seekers: Native American Visionary Traditions of the Great Plains*. Norman: Oklahoma Press, 1994.

Ito, Atsunori. "Marketing Hopi Jewelry in Japan: An Analysis of the Promotional Characteristics of Hopi Arts and Crafts in/to Japan." *European Review of North American Studies* 19, 1 (2005): 45-48.

Jenkins, Philip. *Dream Catchers: How Mainstream America Discovered Native Spirituality*. New York: Oxford University Press, 2004.

Jenness, Diamond. "Eskimo String Figures." *Journal of American Folk-Lore* 36 (1923): 281-294.

——————. *The Ojibwa Indians of Parry Island, Their Social and Religious Life*. Ottawa: National Museum of Canada, 1935.

Jennings, John, ed. *The Canoe: A Living Tradition*. Toronto: Firefly Books, 2002.

Johnston, Basil H. *Tales the Elders Told: Ojibway Legends*. Toronto: Royal Ontario Museum, 1981.

Jones, William. "Ojibwa Tales from the North Shore of Lake Superior." *Journal of American Folk-Lore* 29 (1916): 368-391.

King, J. C. H. "North American Ethnography in the Collection of Sir Hans Sloane," in *The Origins of Museums*, edited by O. Impey and A. MacGregor, 232-236. Oxford: Oxford University Press, 1985.

——————. "Marketing Native North America: The Promotion and Sale of Art and Design." *European Review of North American Studies* 19, 1 (2005): 1-4.

King, Stephen. *Dreamcatcher*. New York: Scribner, 2001.

Klein, Cecilia F. "The Snares of Mictlan: Aztec Cosmology as a Means of Social Control" (paper presented at the Douglas Fraser Memorial Symposium on Primitive and Pre-Columbian Art. New York City, 1983).

——————. "Snares and Entrails: Mesoamerican Symbols of Sin and Punishment." *Res* 19/20 (1990): 81-104.

Kohl, Johann Georg. *Kitchi-Gami: Life Among the Lake Superior Ojibway*. St Paul: Minnesota Historical Society Press, 1985 [first published in 1860].

Krech, Shepard III. "The Fifth Earl of Lonsdale's Ethnographic Collection: Some Late Nineteenth Century Biases." *Arctic Anthropology* 28, 1 (1991): 34-47.

Landes, Ruth. *The Ojibwa Woman*. New York: W.W. Norton & Company, 1971.

Lightwood, David, compiler. *Legends of the James Bay Lowlands*. Timmins: James Bay Education Centre, 1976.

Lowie, Robert H. "The Material Culture of the Crow Indians." *Anthropological Papers of the American Museum of Natural History*, Vol. 21, Part 3 (1922).

Lumholtz, Carl. "Symbolism of the Huichol Indians." *Memoirs of the American Museum of Natural History* 3 (1900): 1-228.

Lyford, Carrie A. *Quill and Beadwork of the Western Sioux*. Washington, D.C.: United States Department of the Interior, 1940.

McBride, Bunny. *Molly Spotted Elk: A Penobscot in Paris*. Norman: University of Oklahoma Press, 1995.

McCain, Becky Ray. *Grandmother's Dreamcatcher*. Morton Grove, Illinois: Albert Whitman, 1998.

McClellan, Catharine. "My Old People Say: An Ethnographic Survey of Southern Yukon Territory." Ottawa: National Museums of Canada (Publications in Ethnology No.6, Part 2), 1975.

McCoy, Ronald. *Circles of Power*. Flagstaff, Arizona: The Museum of Northern Arizona, 1988.

——————. "Spiders Are Mysterious: The Spirit of the Spider in Lakota Art and Lore." *American Indian Art Magazine* 34, 2 (2009): 60-71.

Milliea, Mildred. "Micmac Catholicism in My Community: Miigemeoei Alsotmagan Nemetgig." *Actes du Vingtième Congrès des Algonquistes*, edited by William Cowan, 262-266. Ottawa: Carleton University Press, 1989.

Morrow, Patrick and Baiba. "Life in the Shadow." *Equinox*, May/June, 1985: 24-41.

Nagy, Imre. "Lame Bull: The Cheyenne Medicine Man." *American Indian Art Magazine* 23, 1 (1997): 70-83.

Nozedar, Adele. *The Element Encyclopedia of Secret Signs and Symbols.* London: Harper-Collins, 2008.

Oberholtzer, Cath. "Made for Trade: Souvenirs from the Eastern Subarctic." *American Indian Art Magazine* 36, 2 (2011): 56-67.

Painter, John W. *A Window on the Past.* Cincinnati, Ohio. Private publication, 2003.

Pakes, Fraser J. "'Stealing the Culture – With Sensitivity?' The Indian Hobbyist at the Powwow," in *Generous Man* – Ahxsi-tapina: *Essays in Memory of Colin Taylor, Indian Ethnologist,* 169-181. Wyk auf Foehr, Germany: Tatanka Press, 2008.

Parezo, Nancy J. and Karl A. Hoerig. "Collecting to Educate: Ernest Thompson Seton and Mary Cabot Wheelwright," in *Collecting Native America 1870-1960.* Shepard Krech III and Barbara A. Hail, editors, 203-231. Washington, D.C.: Smithsonian Institution Press, 1999.

Parsons, Elsie Clews. "War God Shrines of Laguna and Zuni." *American Anthropologist* 20 (1918): 381-405.

——————. *Pueblo Indian Religion.* Chicago: University of Chicago Press, 1939.

Peers, Laura. *The Ojibwa of Western Canada 1780 to 1870.* Winnipeg: The University of Manitoba Press, 1994.

Phillips, Ruth B. *Patterns of Power: The Jasper Grant Collection and Great Lakes Indian Art of the Early Nineteenth Century.* Kleinburg, Ontario: The McMichael Collection, 1984.

——————. *Trading Identities: The Souvenir in Native North American Art from the Northeast, 1700-1900.* Montreal and Kingston: McGill-Queen's University Press, 1998.

Powers, William K. *Sacred Language: The Nature of Supernatural Discourse in Lakota.* Norman: University of Oklahoma Press, 1986.

Preston, Richard J. *Cree Narrative.* Montreal and Kingston: McGill-Queen's University Press, 2002.

Rand, Silas. *Legends of the Micmacs.* New York and London: Longmans, Green, 1894.

Ray, Carl and James Stevens. *Sacred Legends of the Sandy Lake Cree.* Toronto: McClelland and Stewart, 1988.

Ringland, Mabel Crews. "Indian Handcrafts of Algoma." *Canadian Geographical Journal* 6, 4 (1933): 185-202.

Rogers, Edward S. "The Material Culture of the Mistassini." *Anthropological Series* 80, *National Museum of Canada Bulletin* 218 (1967).

——————. "The Quest for Food and Furs: The Mistassini Cree, 1953-1954." Ottawa: National Museums of Canada (Publications in Ethnology No.5), 1973.

Salinger, Margaret A. *Dream Catcher: A Memoir*. New York: Simon and Schuster, 2000.

Schmalz, Peter S. *The Ojibwa of Southern Ontario*. Toronto: University of Toronto Press, 1991.

Simms, S. C. "Myths of the Bungees or Swampy Indians of Lake Winnipeg." *Journal of American Folk-Lore* 19 (1906): 334-340.

Skinner, Alanson. "Notes on the Eastern Cree and Northern Saulteux." *Anthropological Papers of the American Museum of Natural History* 9, Part 1 (1911).

Smith, Donald. *Long Lance: The True Story of an Imposter*. Toronto: Macmillan, 1982.

—————. *From the Land of Shadows: The Making of Grey Owl*. Saskatoon: Western Producer Prairie Books, 1990.

Speck, Frank G. *Naskapi: The Savage Hunters of the Labrador Peninsula*. Norman: University of Oklahoma Press, 1935.

—————. *The Iroquois: A Study in Cultural Evolution*. Bloomfield, Michigan: Cranbrook Institute of Science, 1945.

Speck, Frank G. and George G. Heye. *Hunting Charms of the Montagnais and the Mistassini*. Indian Notes and Monographs 13. New York: Museum of the American Indian/Heye Foundation, 1921.

Spence, Lewis. *Myths of the North American Indians*. New York: Farrar and Rinehart, 1932.

Stewart, John James. *Dream Catchers: A Journey Into Native American Spirituality*. Nashville, Tennessee: Premium Press America, 2009.

Tanner, Adrian. *Bringing Home Animals*. St. John's: Memorial University of Newfoundland, 1979.

Tanner, Helen Hornbeck. *The Ojibwas*. Bloomington: Indiana University Press, 1976.

—————. *The Ojibwa*. New York and Philadelphia: Chelsea House Publishers, 1992.

Taube, Karl. "The Teotihuacan Spider Woman." *Journal of Latin American Lore* 9, 2 (1983): 107-189.

Taylor, Colin. "The Indian Hobbyist Movement in Europe." In *Handbook of North American Indians: History of Indian-White Relations*, Vol. 4, edited by Wilbur E. Washburn, 562-569. Washington, D.C.: Smithsonian Institution Press, 1988.

Taylor, Drew Hayden. "Kitsch Catchers." *NOW* magazine, Online Edition 24, 31 (2005): 1-3.

Theriault, Madeline Katt. *Moose to Moccasins*. Toronto: Natural Heritage/Natural History, 1992.

Toor, Frances. *A Treasury of Mexican Folkways*. New York: Crown Publishers, 1947.

Vaughan, Alden T. *Transatlantic Encounters: American Indians in Britain 1500-1776*. New York: Cambridge University Press, 2006.

Waller, Sam. *Indian Legends*. Sam Waller Museum (Le Pas, Man.): PA83.17.5, 1930.

Wallis, Wilson D. and Ruth S. Wallis. *The Micmac Indians of Eastern Canada*. Minneapolis: University of Minnesota Press, 1955.

—————. "The Malecite Indians of New Brunswick." *Anthropological Series* 40, *National Museum of Canada Bulletin* 148 (1957).

Webber, Alika Podolinsky. "The Healing Vision: Naskapi Natutshikans." In *Stones, Bones and Skin: Ritual and Shamanic Art*, edited by Anne Trueblood Brodsky, Rose Daneswich and Nick Johnson, 118-121. Toronto: The Society for Art Publications, 1977.

Wernitiznig, Dagmar. *Europe's Indians, Indians in Europe: European Perceptions and Appropriations of Native American Cultures from Pocahontas to the Present*. Lanham, Maryland: University Press of America, 2007.

White, Leslie. "The Acoma Indians," in *Forty-Seventh Annual Report of the Bureau of American Ethnology, 1929-1930* (1932): 17-192.

Whitehead, Ruth H. *Stories from the Six Worlds: Micmac Legends*. Halifax: Nimbus Publishing, 1988.

Williams, Lucy Fowler, William Wierzbowski and Robert W. Preucel, eds. *Native American Voices on Identity, Art, and Culture: Objects of Everlasting Esteem*. Philadelphia: University of Pennsylvania Museum of Archaeology and Anthropology, 2005.

Woerpel, Loren. "Dream Catcher Earrings." *Whispering Winds* 33, 4 (2003): 22-23.

Photo Credits

Front cover: *Breeze* by Nick Huard. Photograph by Pierre Dury.

Back cover, clockwise from top left:

Courtesy Royal Alberta Museum, Edmonton, Canada, Ethnology Program. Photographs by Ruth McConnell — Ainu from Japan; H72.41.1a, Green Beaded Dream Catcher; H75.27.11a,b, Moss bag with Dream Catcher Attached

97285865 © Petr Jilek/ www.shutterstock.com

Flying Head by Nick Huard. Photograph by Jan Thijs

123RF

page 87: 7927519 © Christopher Meder/123rf.com

American Museum of Natural History

page 54: AMNH:502/1938. Ojibwa charm, spiderweb, pre-1919

page 55, top: AMNH:502/1776. Field No. 157, Ojibwa charm, spiderweb beaded, pre-1920

page 55, bottom: AMNH:502/1777

page 69, top: AMNH 50.1/292 ABC; Game, netted hoop and two sticks; Zuni

page 69, bottom: AMNH 50. 1/291 AB; Game, netted hoop and sharpened stick; Hopi

Canadian Museum of Civilization

page 13: Earrings, made by Anne Michell, Nlaka'pamux. CMC, II-C-878, S94-7224

page 17: Necklace, made by Anne Michell, Nlaka'pamux. CMC, II-C-880, S94-7224

page 40: Charm, made by Jane Weistche, Eastern Woods Cree, 1962 CMC, III-D-108, D2004-26001

page 46: Child's necklace, made by Louisa Cheezo, Eastern Woods Cree, 1962. CMC, III-D-126, D2004-26044

page 108: Dreamcatcher, CMC, 2003.78.16, D2003-07007 (Note reads: Kahnawake Mohawk Nation/ Malie/2000/Looking Glass/Pierre Elliott Trudeau avec/with)

page 110: "Catch Your Dreams" poster, University of South Dakota, CMC I-A-341, S96-20759. This promotional poster, circa 1995, appears courtesy of the University of South Dakota

fotoLibra

page 106: Photograph © Peter Bassett/ fotoLIBRA.com

Getty Images

page 125: 10173055 Photograph © Grant Faint/Getty Images

Glenbow Archives

page 21: NA-1681-6

page 35: NA-1406-170

page 90: NA-1183-7

page 91: NA-2573-1

page 93: NA-1811-80

page 96: NA-3965-37

page 99: NA-3164-351

page 100: NA-4868-213

Library and Archives Canada
page 19: C-114480. Acc. No. 1981-55-76 Bushnell Collection. *Ojibway Indians Shooting the Rapids*, 1875; oil on canvas, Frederick Arthur Verner, 1836-1928
page 129: C-002692. Ojibway woman wearing the cradle in tribal fashion at the play "Hiawatha" held near Sault Ste. Marie, Ontario. circa 1920

Michael Cullen
page 27: Photograph © Michael Cullen

Museum of Archaeology and Anthropology, University of Cambridge, U.K.
page 114: Dreamcatcher 2004.59. Photograph by Jocelyne Dudding

National Museum of the American Indian
page 66, top: NMAI T009049_2. Photograph by R.A. Whiteside

Parks Canada
page 64: Courtesy Parks Canada, 9K998A1-1

Royal Alberta Museum
page 75: H98.2.7, Dream catcher from Mission, B.C., RAM, Edmonton, Canada, Ethnology Program. Photograph by Ruth McConnell
page 120: H02.129.22, Ainu from Japan, RAM, Edmonton, Canada, Ethnology Program. Photograph by Ruth McConnell
page 40, bottom right: H72.41.1a, Green Beaded Dream Catcher, RAM, Edmonton, Canada, Ethnology Program. Photograph by Ruth McConnell

[Royal Alberta Museum cont.]
page 42: H75.27.11a,b, Moss bag with Dream Catcher Attached, RAM, Edmonton, Canada, Ethnology Program. Photograph by Ruth McConnell

Royal Ontario Museum
page 40, top right: 966.73.19: Baby charm (wood, babiche), circa 1966; Photo: Jordan Craig © ROM; ROM2012_12594_1

Shutterstock
page 39: 97285865 © Petr Jilek/ www.shutterstock.com
page 109: 14284 © JEO/www.shutter-stock.com

Smithsonian Institution National Museum of Natural History
page 50: NMNH. E395312-0.27. Accession Number 211312. Slide number 75-10109
page 61: NMNH Imaging, E289081-0. Accession Number 061452. Photograph by Donald E. Hurlbert
page 83: NMNH E165859. Slide number 89-10274

University of Pennsylvania Museum of Archaeology & Anthropology
page 62: Courtesy of the Penn Museum, Object No. 38-1-1, Image No. 151948
page 66, bottom: Courtesy of the Penn Museum, Object No. 37166
page 70: Courtesy of the Penn Museum, Object No. 38505

Index

LINDENHURST MEMORIAL LIBRARY

3 1801 00507 5589

10-18

LINDENHURST MEMORIAL LIBRARY
LINDENHURST, NEW YORK 11757